WINSON GREEN to BROOKFIELDS
THROUGH TIME
Ted Rudge

AMBERLEY PUBLISHING

First published 2009

Amberley Publishing
Cirencester Road, Chalford,
Stroud, Gloucestershire, GL6 8PE

www.amberley-books.com

British Library Cataloguing in Publication Data.
A catalogue record for this book is available from the British Library.

ISBN 978 1 84868 132 3

Typesetting and Origination by Amberley Publishing.
Printed in Great Britain.

Foreword

For most of Birmingham's history, what was known as Birmingham Heath was a great swathe of open land that was little cultivated and which lay well away from the built-up areas of the town. Today it is only recalled in Heath Street, but once this wasteland stretched from what became the Dudley Road in the west to the Hockley Brook in the east – across which lay Handsworth Heath. Its northern limit was about where Winson Green Road, Lodge Road and Bacchus Road would run, whilst to the south its border approximately followed the line of the modern Clissold Street and All Saints' Street.

The northern section of Birmingham Heath later became Gib Heath, whilst part of its southern reaches around the forthcoming Crabtree Road were drawn into Brookfields. The rest of the heathland was pulled into Winson Green. Originally this was that area which bordered Smethwick and through which the Winson Green Road would be cut. This name was noted first in 1327 when a William de Wynesdon was recorded as one of the people in Birmingham who were taxed 'to the amount of one twentieth of their movables as a subsidy for the defence of the kingdom against the Scotch'.

His surname indicates that he was of Wynesdon and that this place was known locally. In the Warwickshire volume of the English Place Name Society it is suggested that it may mean the hill, 'don', of a man called Wine. However, Joe McKenna who has researched many of Birmingham's place names feels that a better explanation is that Wynesdon is derived from the Old English word 'winn' meaning a meadow. Thus Winson Green would be meadow hill green. Certainly, the land drops quite sharply to the north of Winson Green Road and as the Handsworth New Road it runs down towards the valley of the Hockley Brook. This topographical feature supports both interpretations as far as the 'don' element of Wynesdon is concerned. It remains debateable as to which case is the stronger for the origin of 'Win'.

Another question arises: how did Wynesdon become Winson? Locally Bordesley was pronounced with a barely discernible 'd' so that it became Bor'sley. Similarly, it is most likely that Wynesdon was spoken as Wynes'n. This shift is indicated by two documents separated by only thirty years. In 1592, John Barebon of Wynsdon Greene leased land from Ambrose Phillips, whilst in 1622, Sir Walter Erle and his wife Anne conveyed to Edward Bests, a smith of 'Wynson greene' in the parish of Birmingham, premises and lands at Winson Green and Smethwick. As for the 'Green' element in the name, Birmingham has many greens indicating spots where Anglo-Saxon and Middle English folk settled on land which was better and easier to cultivate than the surrounding heath or localities of heavy clays. Winson Green is no exception. It was a green amidst the mostly barren Birmingham Heath.

Birmingham Heath remained a great open space of 289 acres until the later eighteenth century, but change was ahead. Its western boundary was the road from Birmingham to Dudley and in 1727 this was said to be greatly used for the carriage of iron goods, coal and lime. From 1760 the route was run by the Dudley, Birmingham and Wolverhampton Turnpike which was supposed to pay for

the upkeep of the road from the tolls it levied on travellers. However, in 1781 William Hutton was scathing of its condition, deriding it as 'despicable beyond description'. By this date the Birmingham Canal also wound its way through the district. Partly opened in 1769 it necessitated a bridge on the Dudley Road. First called Navigation Bridge, it then became known as Winson Green Bridge.

As the century drew to a close, in 1798 the Loyal Birmingham Associations of Cavalry and Infantry, a forerunner of the Territorial Army, presented their colours on a large piece of cleared land 'on Birmingham Heath, near to Winson Green'. That same year the transformation of the district was heralded by an act of parliament for the enclosure of what had previously been common land. The document mentioned a Pig Mill Lane which seems to have run close by the modern Handsworth New Road.

Then in 1810 the Street Commisioner's Map indicated the appearance of Winson Green Road, based on an ancient path, as well as Lodge Road, Park Road and Bacchus Road, but apart from Shakespeare's Glass House and two large houses called Ninevah and Bellefield there were no prominent buildings. The only hamlet as such was Winson Green, at the junction of the Winson Green Road and the future Wellington Street. There were also a few houses along the top end of Lodge Road.

Charles Pye brought to view the look of the area in 1818 in his *Description of Modern Birmingham*. In one walk he took his readers westwards out of the built-up part of the town, beyond the Sandpits and Spring Hill and along the Dudley Rod. After crossing the still relatively new Birmingham Canal the traveller entered what had been Birmingham Heath.

> On the right hand is a boat-builder's yard, and on the left a glass-house, belonging to Messrs. Biddle and Lloyd. Proceeding towards the windmill, you perceive, at a short distance on the right hand another glass-house, belonging to Messrs. Shakespear and Fletcher. Ascending the hill, there is on the right an extensive view over the adjacent country, including Barr-beacon, Mr. Boulton's plantations and Winson-green, a neat house, in the possession of Mrs. Steward. On the left is Summerfield-house, late the residence of John Iddins, Esq. but now of James Woolley, Esq. and beyond it, a neat white house, occupied by Mr. Hammond. Over an apparently wooded country, you have a windmill in full view, and when at the foot of the hill, on the right is Smethwick grove, the residence of John Lewis Moilliet, Esq.

Moilliet Street recalls this latter home which belonged to a banking family from Switzerland, whilst the windmill is brought to mind in a pub on the Dudley Road.

The largely rural outlook of Winson Green was little changed by the time of White's *History, Gazeteer and Directory of Warwickshire* in 1850. However, four years later there was a remarkable

difference. A railway linking Birmingham and Wolverhampton was made. A contemporary wrote that Winson Green 'became a wilderness of sand and brickwork, deep cuttings at one end and high embankments at the other completely altered the appearance of the spot'.

By now housing was beginning to be built, and Piggott Smith's map of 1855 shows Villiers Street added to the old hamlet and a new area of housing focused on Landowne Street. To the west of this locality, Winson Street, Tudor Street and Cape Street had appeared and by Till's map of 1884 they had been joined by Dugdale Street and others. Fields still occupied the land between Winson Street and the Winson Green Road, as they did between the Handsworth New Road and Bacchus Road. However, Hart Street and others had come into view nearby as had the Talbot Street neighbourhood. Twenty years later, the urbanisation of Winson Green had been completed with the development of the Cuthbert Road and Willies Road localities.

The built-up area of Winson Green and Brookfields was largely upon land which had been cultivated. By comparison, the old heathland was mostly dominated by major buildings: the Borough Prison was opened in 1849; the Borough Asylum, later All Saints', followed two years later; and the workhouse opened in 1852. These took up nearly 100 acres. Finally, from 1883-4 the Borough Hospital for Smallpox and Scarlet Fever was in use. This and All Saints' have now closed, and whilst the prison remains, thankfully the hated workhouse has gone and in its place is the City Hospital (Dudley Road Hospital).

Originally developed as a better-off working-class district, back-to-backs were numerous in parts of Winson Green. However, because many of its houses were better built they have survived and as a result the neighbourhood has witnessed less clearance and more urban renewal in the later twentieth century than the nearby Brookfields, Ladywood and Hockley. Despite the importance of its major buildings, and despite its proximity to the city centre (less than two miles away), the people and districts of Winson Green and Brookfields have been much neglected in the history of Birmingham. That will no longer be the case thanks to the work of Ted Rudge, his website and this book. Ted's indefatigable efforts as a prominent local historian are ensuring that Winson Green and Brookfields is brought to the fore as one of the working-class heartlands of the city and that its people take their place proudly as belonging to an important and historic area. They should be proud of Ted and his achievements.

Carl Chinn

Introduction

Winson Green is nationally famous, or infamous, for one reason: the prison. This is not because people have necessarily visited or indeed spent time there; it is because of the notoriety of the establishment. Although the prison dominates one part of the district its effect is minimal on the community living directly outside and around. They are obviously aware of the fortress their homes are surrounded by but what goes on inside they are generally oblivious to. Considerable change has occurred not only to the prison but to Winson Green and the surrounding area. People that were born, raised or made their homes in this area may have experienced various degrees of change, but not everything that has happened through time. Now many of the changes that have taken place are illustrated for the first time in a book, and with the aid of a series of over 180 old and new photographs. Images cover a number of changes that have happened in Winson Green and Brookfields, from the most recent developments of the twenty-first century to the earlier ones that occurred in the mid-nineteenth century.

Birmingham, like many other English contemporary towns, experienced unprecedented growth during the mid-nineteenth century through an influx of people, and their families, seeking regular work and accommodation. Housing an additional 200,000 people between 1831 and 1871 and many thousands that arrived after became a major social problem. This rapid expansion created overcrowded and unsanitary dwellings in the town centre.

Further growth necessitated the use of land away from the centre of Birmingham. One area eventually chosen, known as Birmingham Heath, lay less than three miles to the west of the town. Only the sparsely inhabited hamlet of Winson Green occupied the heath at this time and was considered ideal for development. During the middle of the nineteenth century the Birmingham prison, lunatic asylum and union workhouse were built on the heath. These institutions occupied a large triangle of land across Winson Green and the adjacent district of Brookfields. Private speculators built as many homes for the working class as they could, on as little land as possible, alongside and around the institutions. Canals, railways and the major roads that crisscrossed the districts provided the infrastructure for rapid growth. Development continued, providing churches, schools, shopping areas, public houses and light industry until the early twentieth century when the area became fully developed, and remained so until the 1960s.

The period after 1960 did not see any large scale redevelopment, something that happened in other parts of Birmingham. Winson Green and the immediate area around it are to this day still undergoing regeneration. Shopping areas that once dominated the major roads have been, or are awaiting, replacement, some by modern council houses. Local corner shops that once provided for the working class families have nearly all disappeared without replacement. Public houses that were frequented by loyal local customers could have been found in most streets, but they have now been demolished and not replaced. Much of the light industry that provided employment for the original migrants has

been relocated or replaced with modern shed-like buildings. Not all church buildings have survived either, some were demolished whilst others have been altered or new ones built.

The area has never had more than six large houses with sizable grounds, they were Summerfield, Bellefield, Winson Green, Spring Hill and Nineveh and one called Hockley Abbey, and regrettably none have survived. Prior to 1960 small back to back or terraced houses with one room down and two up filled the side streets. Larger terrace-type houses with gardens at the rear could be found on the main roads but detached-type houses were rare. In comparison with present day building standards social housing was sub-standard from the beginning. Although the original families that resided there found them adequate for their needs, the families living in them over 100 years later may not agree. There were no bathrooms or readily available hot water in the majority of houses. Families shared outside toilets with their neighbours and their rubbish was dispose of in communal outdoor areas. They shared the outdoor facilities provided to launder the family clothes, and many did not have gardens to hang the washing out in.

Very little of Winson Green and Brookfields has ever been green, only three open spaces were available to the community locally. Summerfield Park, with extensive lawns and flower beds, was the largest, located in the Rotton Park district of Birmingham which borders Winson Green. Another place of recreation could be found at Black Patch Park located on the Smethwick (Staffordshire) and Winson Green border since 1912. Passing through this park is the only local source of flowing water known as the Hockley Brook. Regrettably, this mainly grassless park, initially financed by Birmingham people, was the subject of a boundary change in the 1960s and became part of Sandwell UDC (Staffordshire). In contrast, and by far the smallest, was the two-tiered Musgrave Road recreation ground (the Rec.). The lower part of this recreation ground had a Tarmac surface in stark contrast to the crown bowling green available at the higher level. It is ironic that following the post-1960s developments fewer families were housed with gardens, yet more open green spaces were provided.

Approximately opposite where the new prison main entrance can be found today once stood the original hamlet of Winson Green. Using this as a starting point the book takes a clockwise direction around the area Winson Green became. Some images from the surrounding districts of Smethwick, Handsworth, Hockley, Jewellery Quarter, Ladywood, Rotton Park and Brookfields have also been included. Although these districts were each individually distinct the boundaries blended into each other for work, shopping, leisure and play. Each played a part in the lives of the Winson Green folk that lived through the changes this book portrays.

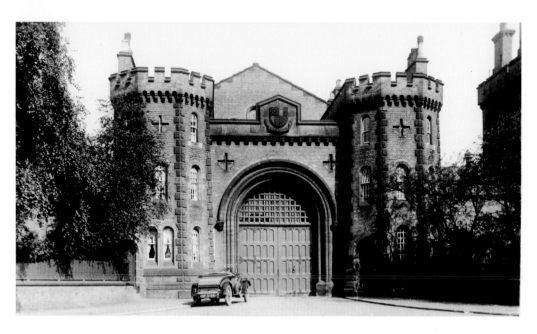

HM Prison Birmingham, Winson Green Road, Winson Green
The Borough Prison, an imposing Victorian structure resembling a medieval castle, was built in 1849 on Birmingham Heath. Set back from the road, two turrets support the main entrance gates. A high brick wall encases the prison dominating this part of Winson Green. Following modernisation in the 1970s the blue replacement domed entrance pillars protrude from a new red brick wall which still dominates Winson Green.

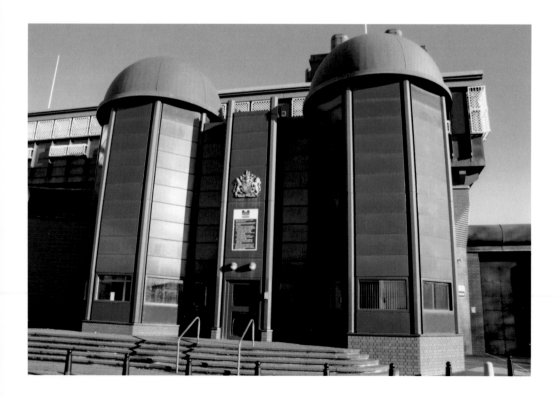

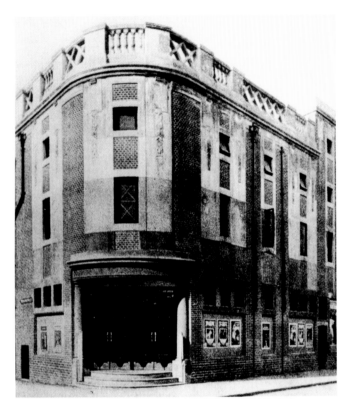

Winson Green Picture Palace
Ironically a place where many thousands of people gathered over a forty-five year period for entertainment was also where the hamlet of Winson Green (Wynesden) once stood. The picture house located directly opposite the prison on the corner of Wellington Street closed on 20 March 1959. Then, after serving as a tool hire business the building was eventually demolished in the 1970s. Now occupying the site is a LDV specialist housed in a modern shed-like building.

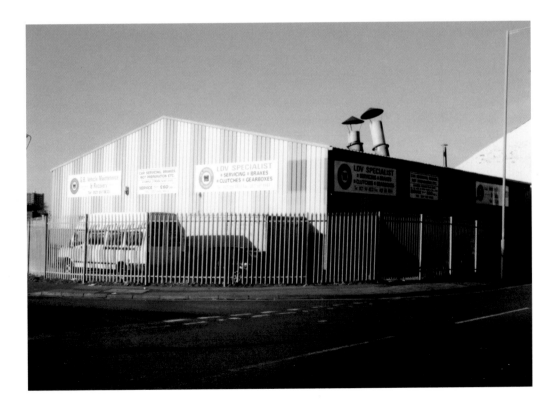

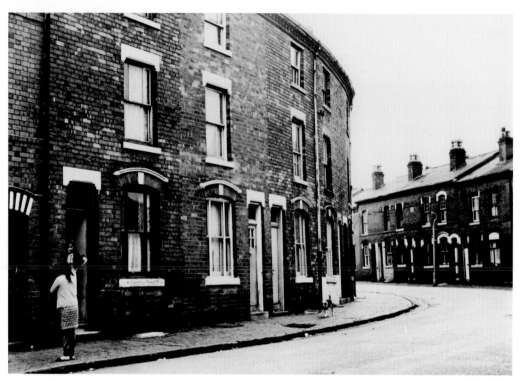

Wellington Street

Bending towards Winson Green Road the street shows the original terrace-type housing found in side streets with the front doors opening directly onto the pavement. Houses on the left have two rooms up and those on the right only one. After the regeneration of this street no houses were provided, only light industrial premises.

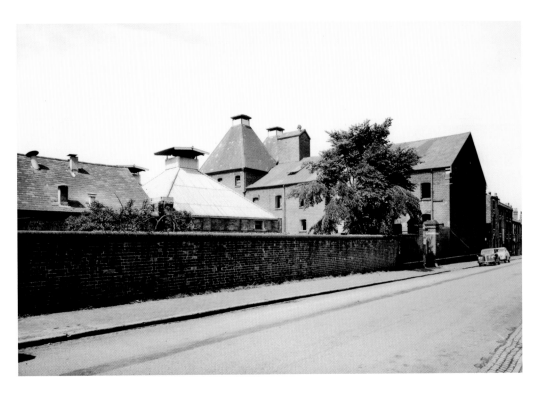

Malt House, Wellington Street

A large Smethwick brewery Mitchell and Butlers (M&B) sited a malting house between the dwelling houses. Hidden from view in the 1959 image, but revealed in the latest one, a railway line exists. This was possibly the reason why the malt house was originally built there.

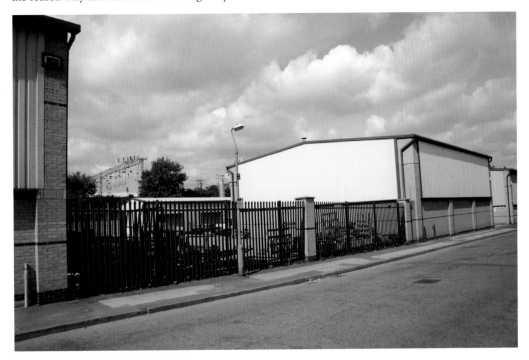

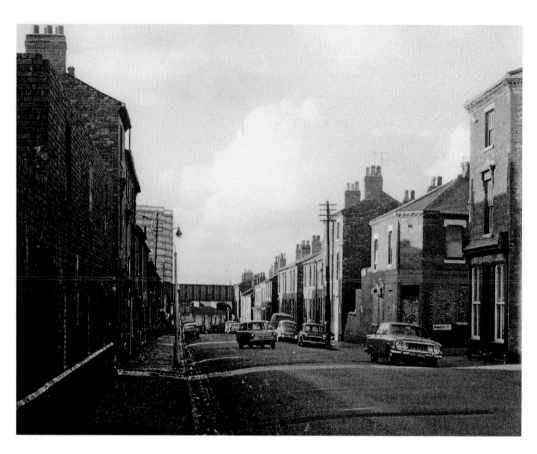

Wellington Street

Wellington Street in 1970 revealed a densely populated street containing back to back and terraced houses with the usual corner shops. Visible behind the railway bridge that spans the bottom end of the street is Merry Hill Court, a block of high rise flats built in Vittoria Street, Merry Hill across the border in Smethwick. Only the bridge remains today together with light industrial premises and a large green open space.

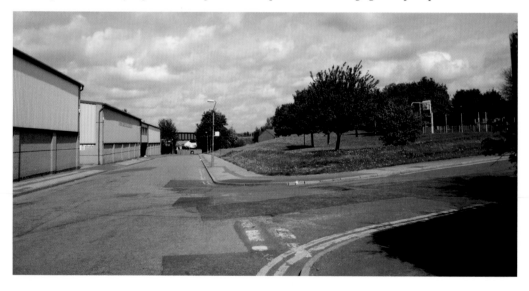

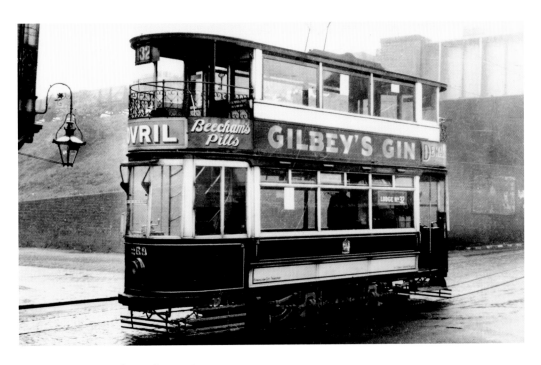

Wellington Street and Foundry Road

Public transport from Birmingham city centre to Winson Green began the return journey from this point. Both the No. 32 tram and the No. 96 bus turned their keys in the Bundy Clock located underneath the bridge in Wellington Street. Beginning of the return journey involved travelling up the Foundry Road (the road on the left in the 2008 photograph) now a cul-de-sac at this point, public transport no longer uses this part of the route.

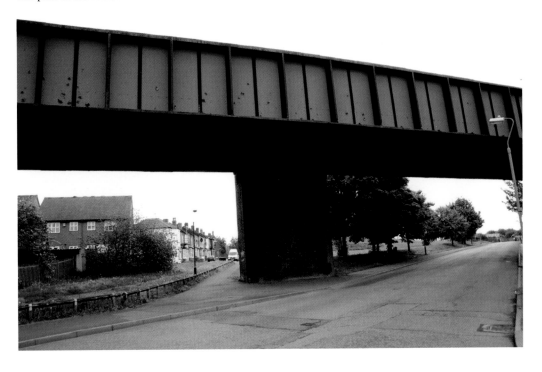

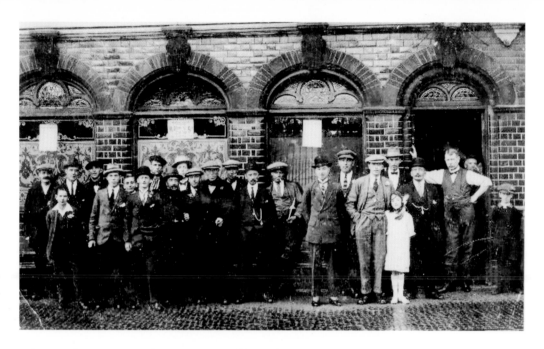

Soho Foundry Tavern, Foundry Lane, Merry Hill, Smethwick

The tavern is located in Foundry Lane opposite the Soho Foundry of which it acquired its name. Matthew Boulton Jr. and James Watt created the foundry in 1796 to cast machinery that powered the English industrial revolution. Workers from the foundry frequented the tavern together with many from the heavy industrial factories based around this area. Current regeneration has left the foundry and the tavern being the only buildings still standing. Customers now frequent the tavern from home rather than from work.

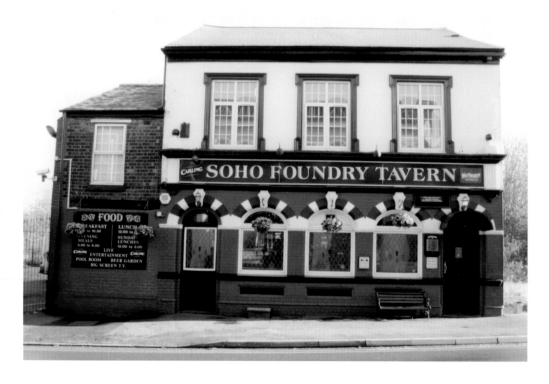

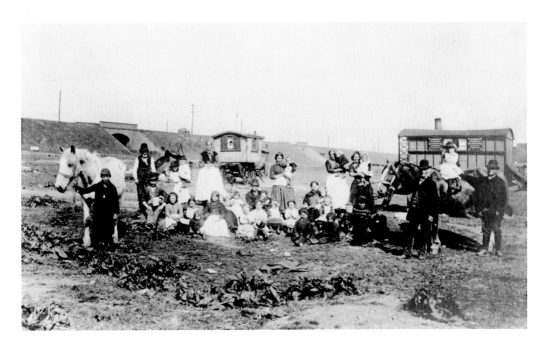

The 'Black Patch', Smethwick

A group of Romany gypsies on the 'Black Patch' in 1895 and the same spot over 100 years later. This was farm land with the Hockley Brook running through. It was reduced to a nineteenth-century industrial tip by the spoils from the foundry furnaces and other local industries. This spoiled land was occupied from the mid-1800s by up to 300 nomadic families – the majority being Romany gypsies. Following two evictions from the land in 1905 and 1907 Birmingham City Corporation cleared and laid it out as a park that opened on 20 June 1911.

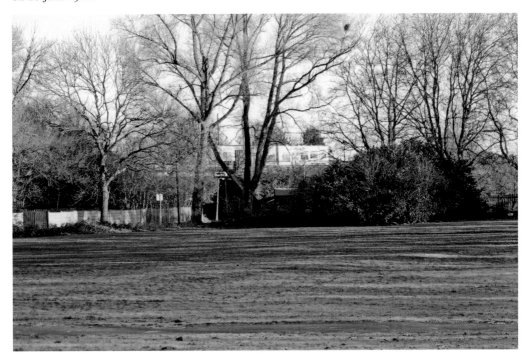

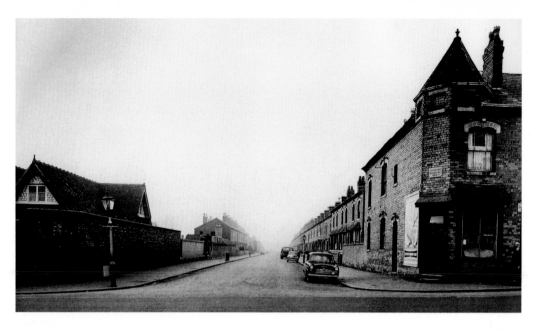

Foundry Road School, Winson Green

Foundry Road School is on the left of this early photograph. Martin and Chamberlain designed the school and it was built by the Birmingham School Board in 1883. Another date can be seen above the shop doorway on the corner of James Turner Street reading 1889. Properties in this location remain as built 125 years later (2009) and the school is still teaching local youngsters.

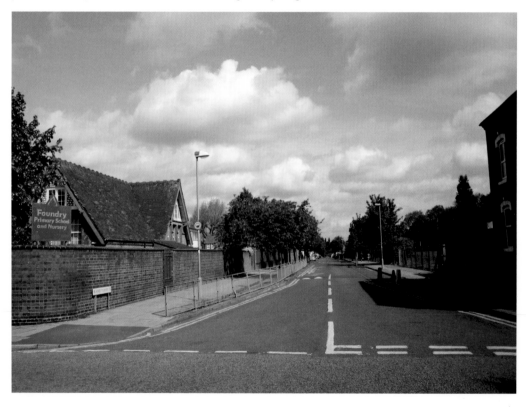

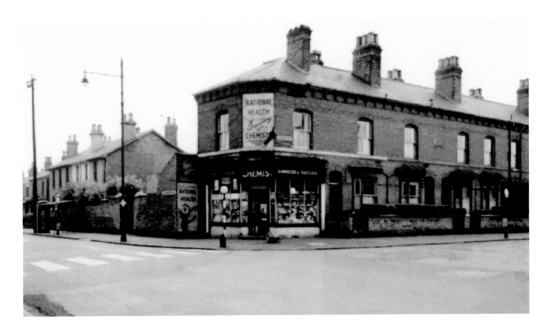

Handsworth New Road and Lodge Road

Another school building, Handsworth New Road Secondary Modern, that opened in 1901 is located on the road to the left. There used to be separate departments for boys and girls with a wall separating the two. Today this building is the Bnai Kanhayya House. The road to the right begins Lodge Road, towards Hockley, linking the prison wall with that of the asylum. Located on both roads can be found the larger terraced housing typically built on main roads with bay windows and a small front garden.

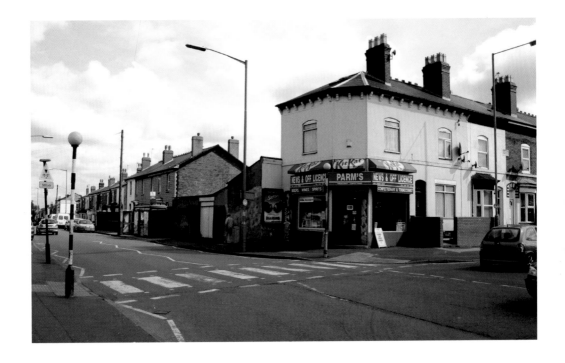

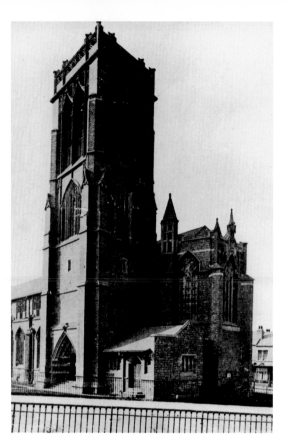

Bishop Latimer Church
In the latest photograph the church is undergoing repairs. This Grade II listed church was designed by W. H. Bidlake and built in 1903/4 on the corner of Beeton Road and Handsworth New Road. In both roads the houses are the original builds with no regeneration having taken place to date in this part of Winson Green.

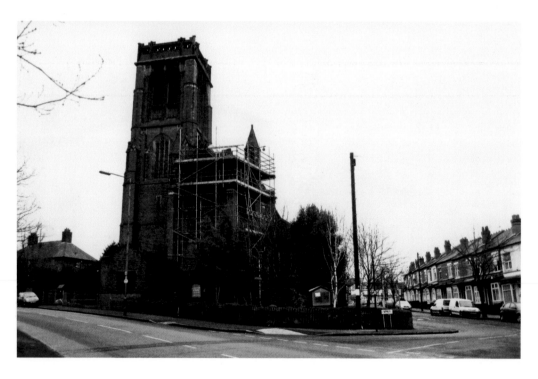

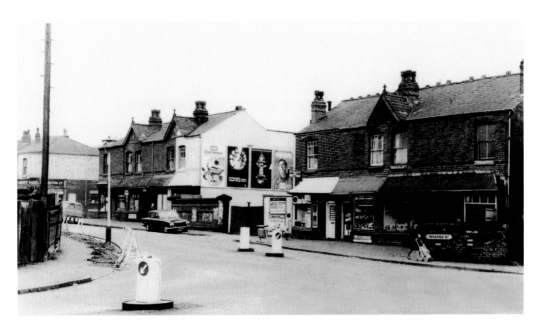

Ninevah Road, Handsworth

Views of Ninevah Road were taken on the Winson Green boundary at the end of Bacchus Road. The Hockley Brook passes under the bridge where the gap in the properties on the right is situated. From the mini roundabout Ninevah Road is in Handsworth.

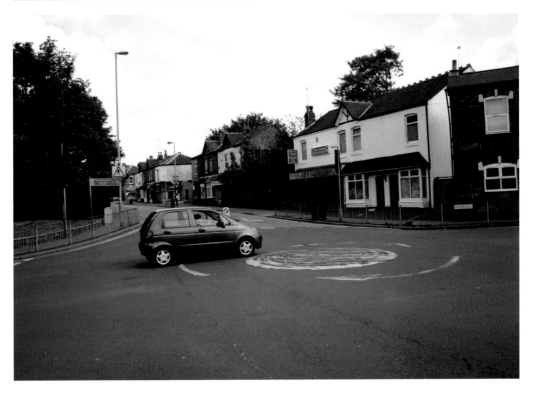

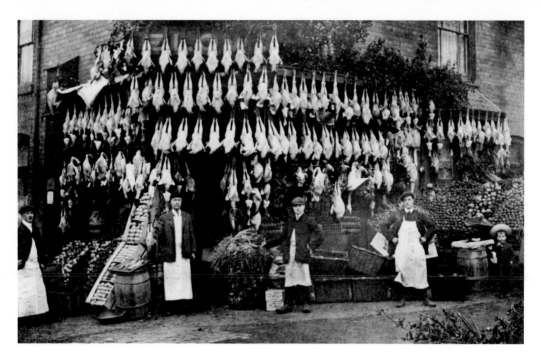

Soho Road, Handsworth

No. 303 Soho Road has been used to sell many types of goods during its lifetime; by 1892 it was greengrocery, then in 1908 a butcher, etc. Present day the property is an Asian dress shop. Soho Road is a large shopping centre known locally as 'the main' or 'main road'. Shoppers from surrounding areas are attracted to 'the main' because of the variety of shops and the goods offered. This road was part of a main highway between London and Holyhead during the coach and horses days.

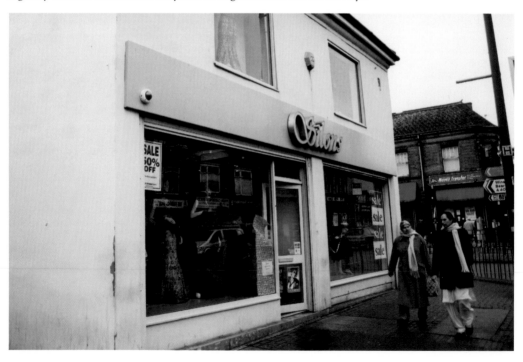

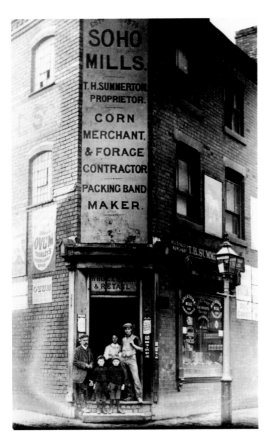

Soho Mills, Berry Street, Winson Green
Soho Mills occupied one side of Berry Street a small street at the rear of Benson Road School with houses on the other side. Following redevelopment the houses were demolished and the new Bacchus Road Park appeared with an entrance near the school.

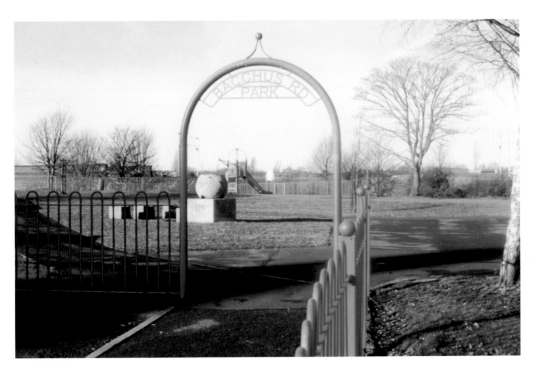

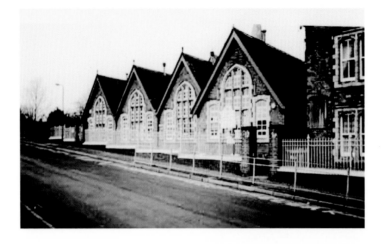

Benson Road School

Benson Road School was built by the Birmingham School Board in 1888 and originally called Soho Road School. The road name changed and so did the school's name. The building was designed by Thomason and Whitwell and is a Grade II listed building. Some small differences are visible externally between the photographs including a satellite dish, alarms and PVC windows.

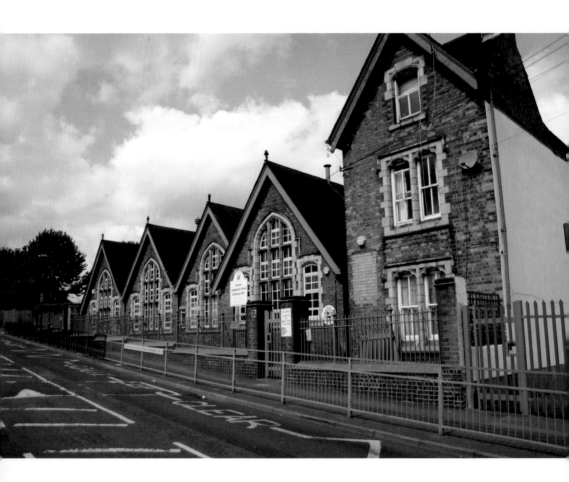

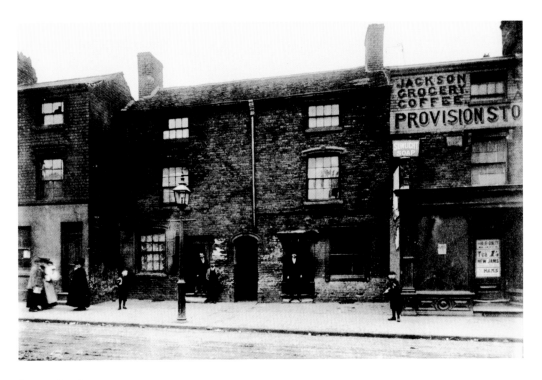

Benson Road

Taken around 1900, this photograph of houses and the Jackson Provision Store displays the price of tea and other produce at this time. In a trade directory Jackson & Co. were first listed there in 1896 with a public house next door called The Wonder Vaults. Families living in the two houses either side of the entry would have shared the washing and other domestic arrangements found in the courtyard at the rear where other families also lived back to back. In contrast the Beulah Hills Apostolic church and car park now occupy this site.

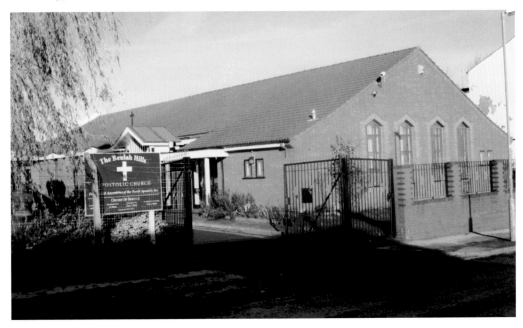

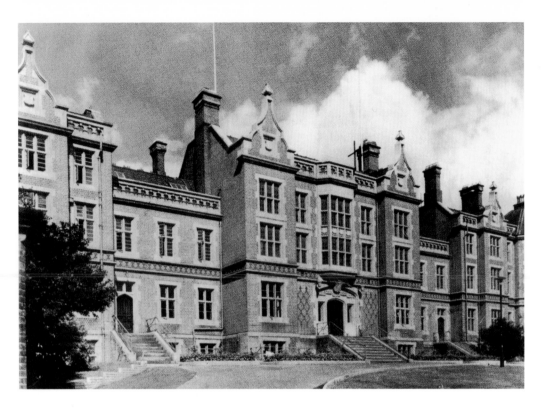

All Saints' Mental Hospital, Lodge Road
Looking like a stately home, this building set in nearly fifty acres of land adjacent to the prison had its own working farm. June 1850 saw the arrival of the first patients to this newly built lunatic asylum later renamed All Saints' Mental Hospital. After the hospital closed in 2001 the buildings were taken over by the prison service. The grounds were converted into a new green open space called All Saints' Park where the later photograph was taken in 2008.

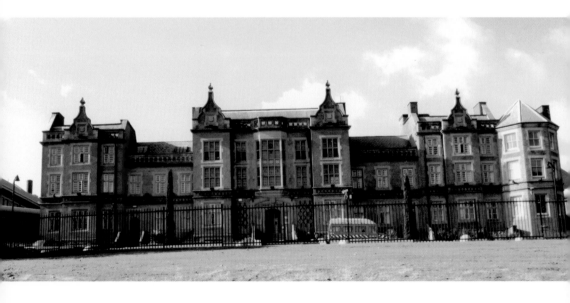

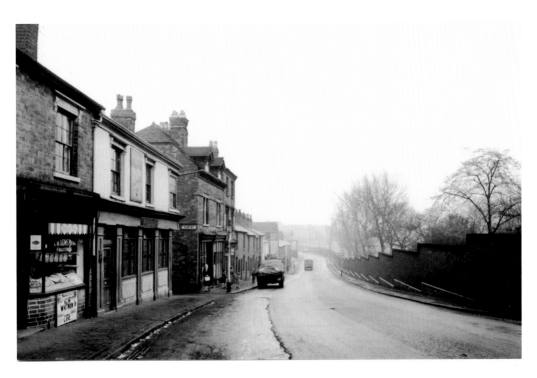

All Saints' Mental Hospital, Boundary Wall, Lodge Road
An imposing eight foot wall occupied one side of Lodge Road and continued along the canal towpath where it joined up with the prison perimeter wall. Although they knew why the wall was there many generations of local people never saw over it until the creation of All Saints' Park. By then on the other side of Lodge Road, Don Street and the Winson Green Tavern public house known locally as 'The Don' plus various shops and houses had been demolished and the area redeveloped.

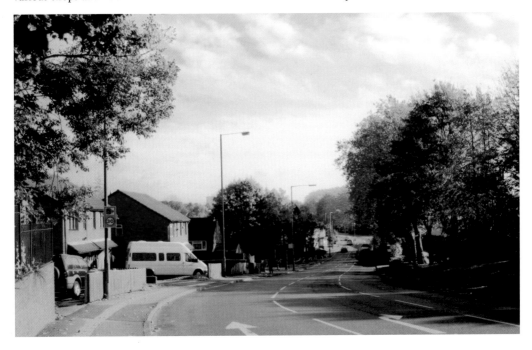

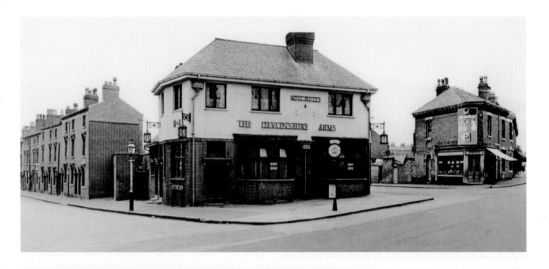

The Devonshire Arms, Lodge Road

This public house survived the redevelopment and is still currently serving customers. The same cannot be said for the street to the right of the pub. Devonshire Street, the origin of the pub's name, no longer exists at this point. Trees now appear along Lodge Road and down the road to the left of the pub Musgrave Road.

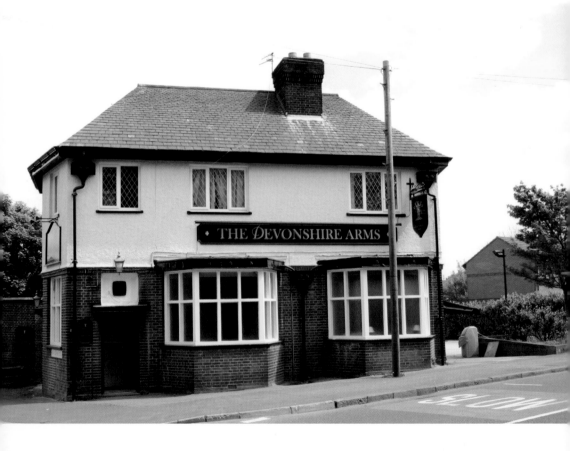

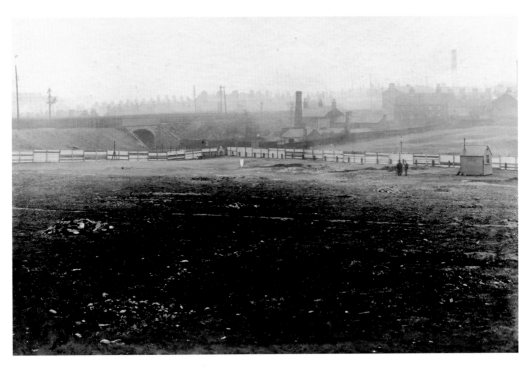

Musgrave Road

A piece of open ground in April 1907 with a railway bank and bridge at the far end is shown in the early photograph. At the railway end industrial premises were built and Musgrave Road was developed with terrace houses and a recreation ground.

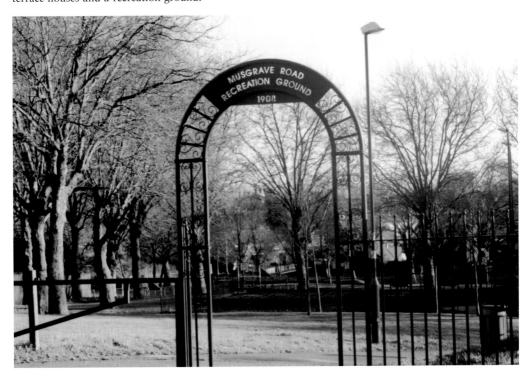

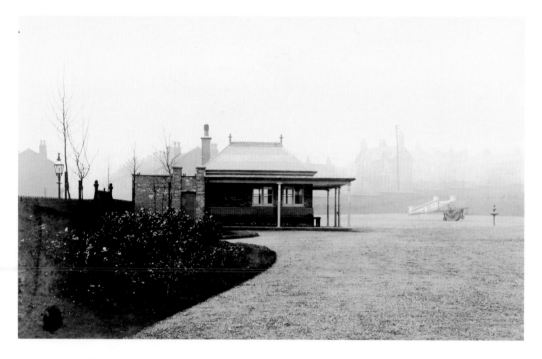

Musgrave Road Recreation Ground

The photograph, dated 14 March 1908, reveals the new recreation ground surrounded by housing and at street level a tarmac surface with steps up to a crown green bowling lawn on a second level. One hundred years later mature trees and a sloping grass surface have replaced the previous landscape with an additional entrance to the recreation ground in Talbot Street.

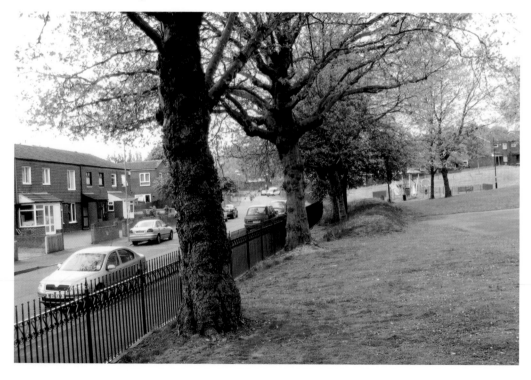

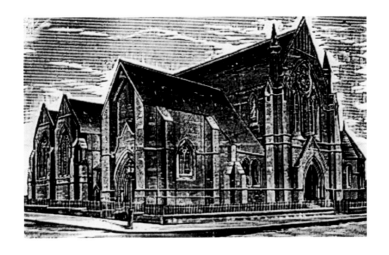

St Chrysostom's Church, Musgrave Road

A factory unit now occupies the corner of Musgrave Road and Park Road were the church once stood. The church was built in 1888 and demolished in the 1970s. The line drawing was taken from the marriage certificate of Thomas Steve Wallis and Annie Eliza Worsey who were married at St Chrysostom's on 20 September 1902. Annie lived in Preston Road, Winson Green, Thomas in Nelson Street, Ladywood.

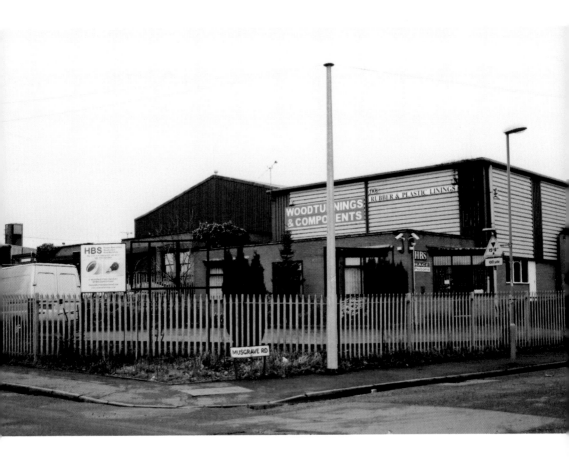

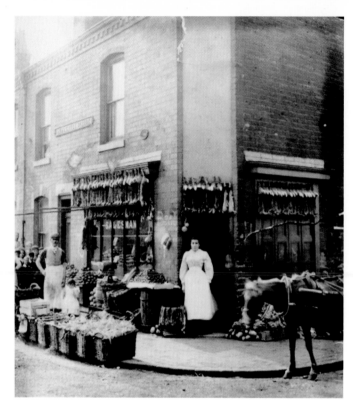

Barratt's Greengrocery Shop, Devonshire Street
Standing proudly outside their greengrocery shop at 131 Devonshire Street with a good selection of produce is Richard Barratt, his wife and daughter Isabella. Their son Richard may have been among the many children that gathered to observe the event in 1901. Today a neat semi detached house has replaced the shop.

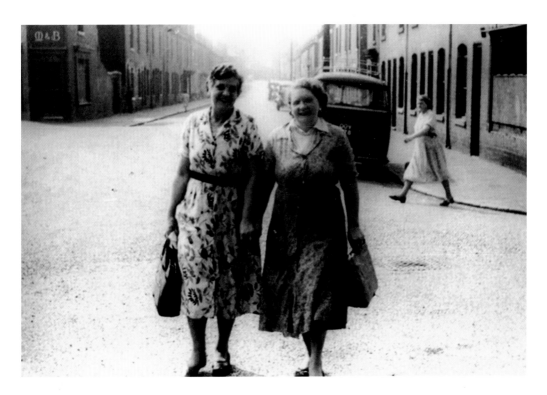

REAL ladies, Devonshire Street

Top right corner of this earlier photograph displays the same shop as the previous 1901 photo (Barratt's Greengrocery), used in the 1950s by Tommy Harper, a local illegal bookmaker. Ida Hands and Laura Leighton walking the short distance to Rowlands Electrical Accessories Limited always referred to as the REAL. Behind them the M&B off license where Lees Street and Devonshire Street meet. This part of Devonshire Street no longer exists in the 2008 photograph.

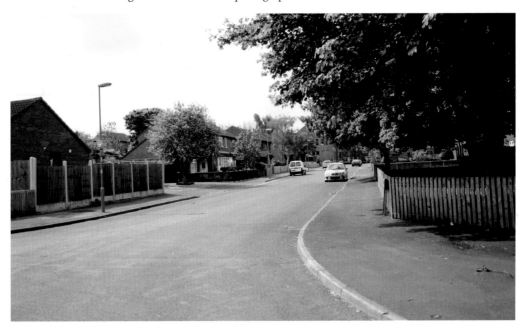

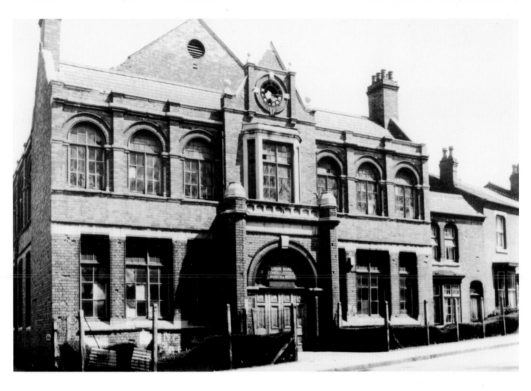

'The Institute', Lodge Road

Always known locally as 'The Institute', the outside of the building showing very little change when all around has been demolished and rebuilt. United Reform services are currently held there.

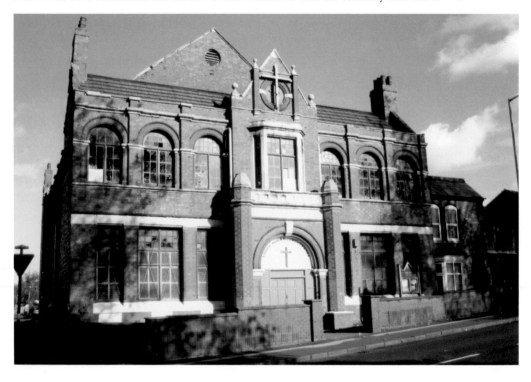

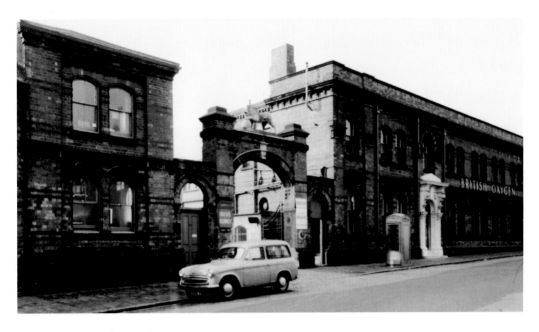

British Oxygen, Lodge Road

Looking majestic, the iconic lion stood balanced with one paw on the stone ball across the main gateway. The premises of British Oxygen in 1950 looked exactly as it did when Kynoch's had a metal rolling mill there in 1900. British Oxygen no longer occupies this site, the buildings and the only public phone box for miles has been replaced by the modern housing, trees and green space of Breadon Croft.

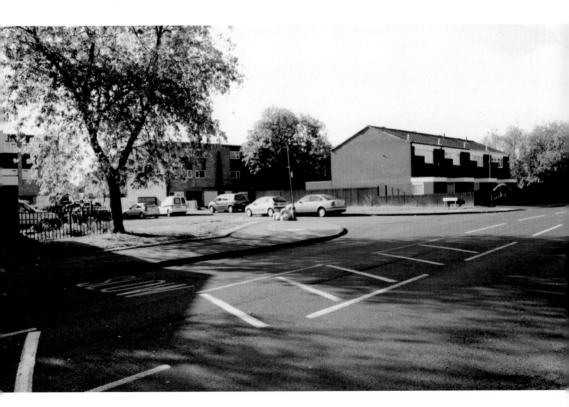

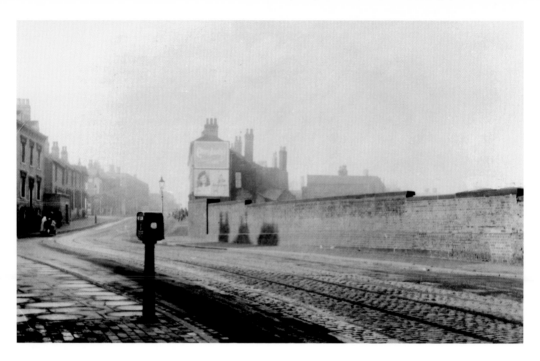

Lodge Road, Abbey Street, Hockley

On the bridge over the Great Western Railway (GWR) stands an early method of alerting the fire brigade. Two sets of tram lines set in cobble stones can also be found in this 1950s photograph. Trams used one set travelling to Birmingham and the other for the return journey. Another long Lodge Road wall is still evident in the 2008 photo continuing to and along Abbey Street.

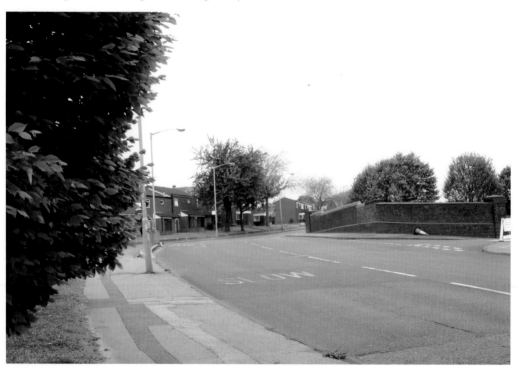

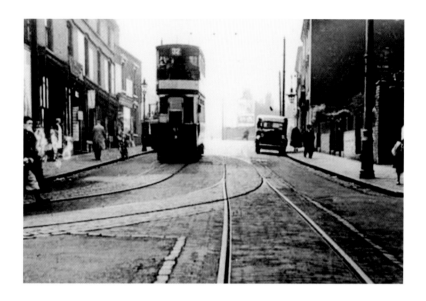

Lodge Road, All Saints' Street, Hockley
No. 32 tram at a request stop outside the shops on Lodge Road having just turned out of All Saints' Street making the return journey from Birmingham. Two straight tracks allow the trams to return to base on completion of the day's journeys. A more rural scene can be found on this corner sixty years later.

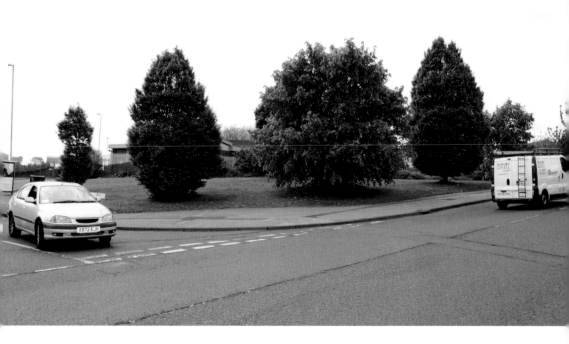

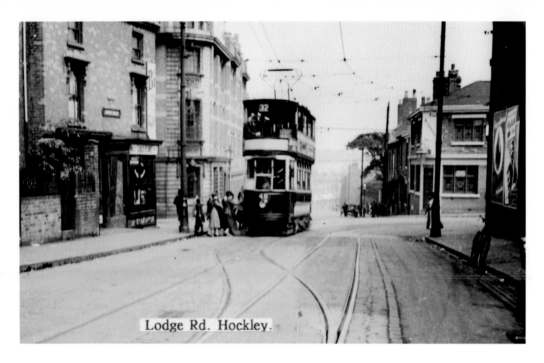

Lodge Rd. Hockley.

Lodge Road, Goode Street, Hockley
Passengers boarding the Birmingham bound tram at the junction of Lodge Road and Goode Street in 1950. Scribbans bakery is on the same corner and The Hydraulic public house on the other, all are missing on the latest photo. Lodge Road continues down a steep hill until the road levels out at the shopping area known as 'the flat'.

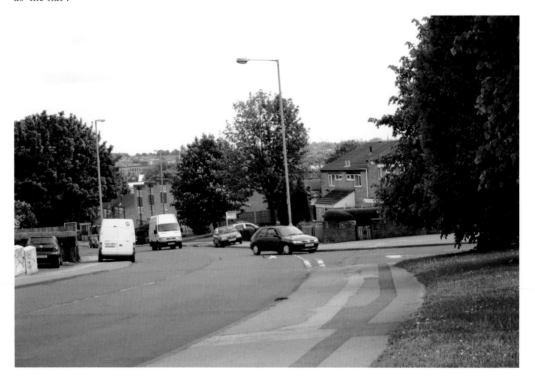

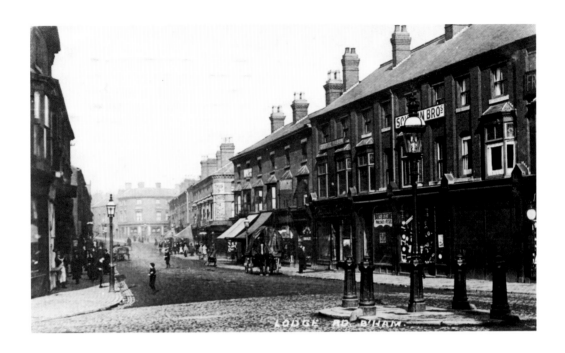

'The Flat', Lodge Road, Hockley

For over 100 years the large variety of shops on 'the flat' has attracted shoppers, young and old, from all the surrounding districts. This all changed after Icknield Street at the end of 'the flat' was made into a duel carriageway, resulting in half the shops being demolished. Centre of the latest photo is a white building, this position on the early photo is the road on the right.

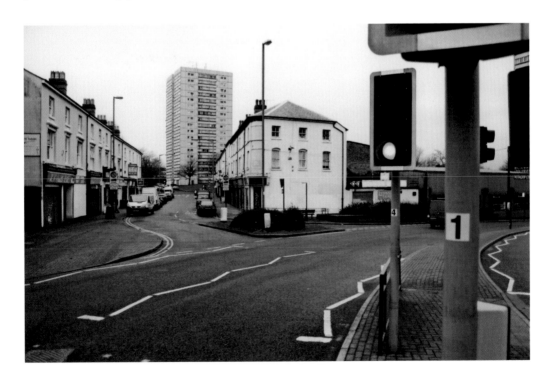

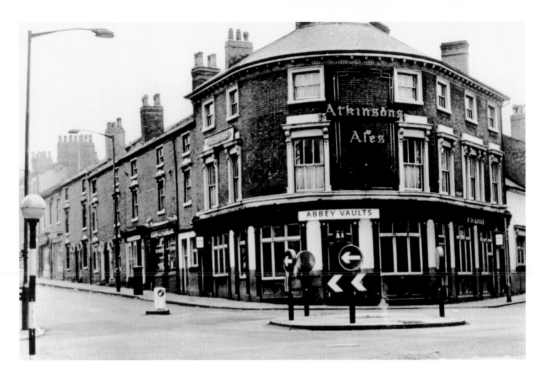

Abbey Vaults, Lodge Road, Park Road, Hockley

Located at the far end of 'the flat', the Abbey Vaults public house and the post office became lost to the area through the regeneration program of the 1960/70s. The photograph taken in 2009 shows the replacement was Norfolk Tower, a multi-storey block of flats. This has led to certain people believing wrongly that the flats were the origin of the term for the locality 'the flat'.

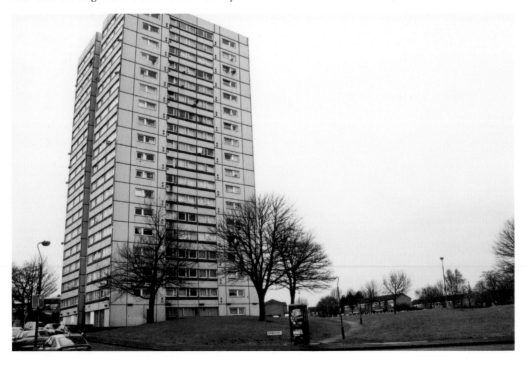

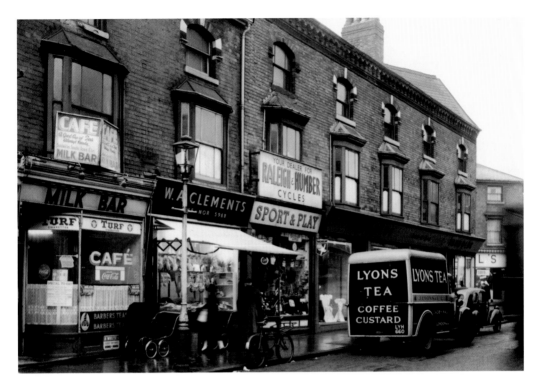

Shops on 'The Flat', 383 to 389 Lodge Road, Hockley
In this 1950s photograph a milk bar, butchers shop, bicycle store and a fashion outfitter are shown trading side by side. On the opposite side of 'the flat' at No. 26 was James Hunt (Baker) Ltd who sold the best 'dripping cakes' and ham for miles. They were typical of the blend of shops to be found on 'the flat'. By contrast in 2009 the original buildings appear altered externally and providing mainly takeaway meals.

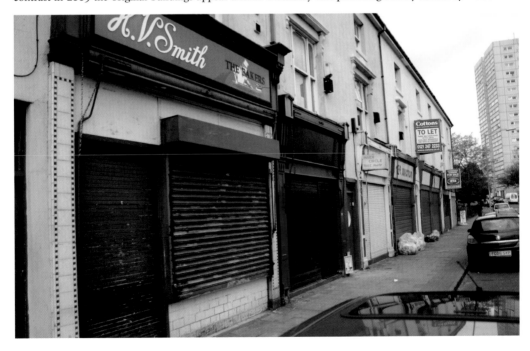

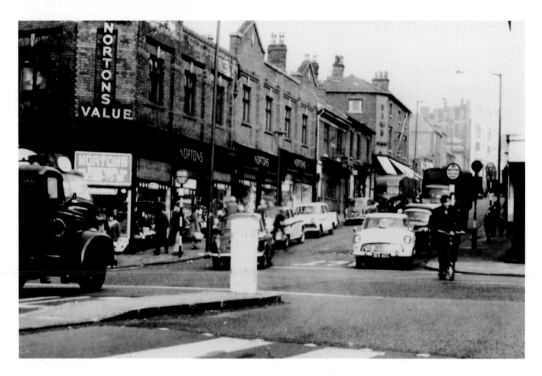

Key Hill, Hockley

Nortons (By-Way Value) department store viewed from the end of 'the flat' across the Icknield Street junction with Key Hill (now a duel carriageway). More shops and industry could be found on either side of this busy hill. At the top right only the Victorian cemetery and the large white Gem Building on the left, dating from 1913, still exists.

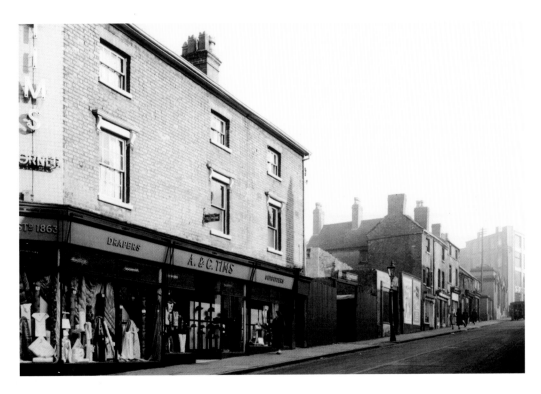

A & C Tims, Key Hill, Hockley

Established in 1863 A & C Tims provided an up market drapery and outfit store displaying their goods in several large windows. The modern buildings that replaced the store face the rundown Key Hill Cemetery. Clearly parking on this hill is now a problem in the 2009 photograph, with double yellow lines each site of the road.

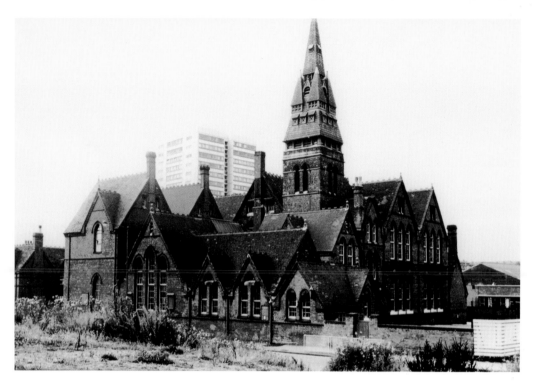

Icknield Street School, Hockley

Built in red brick and terracotta this Grade II listed building designed by J.H. Chamberlain for the Birmingham School Board was opened in 1883. A main entrance is located on Icknield Street near the Hockley flyover and another can be found in Heaton Street. Today the building is no longer used as a school but as the Bhagwan Valmik Ashram Centre.

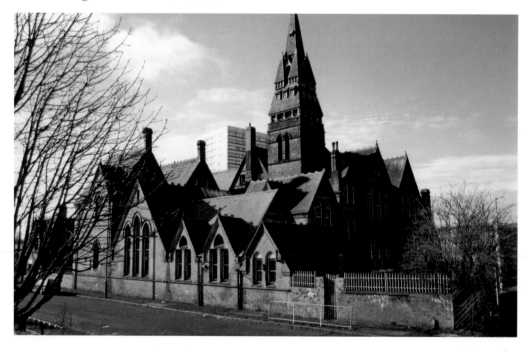

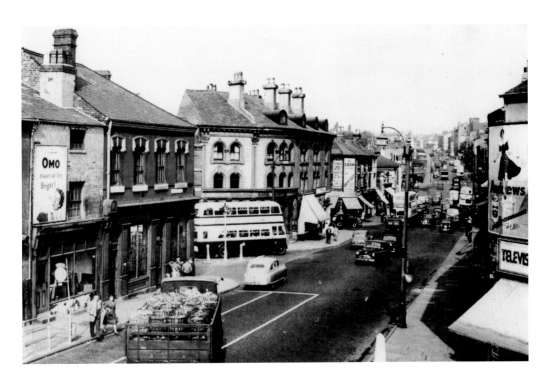

Hockley Brook

As the name suggests there is a brook passing through at this point now in a culvert and not easily visible. However, the traffic converging from the five roads is noticeable in attempting to cross this busy junction, in the 1950s photograph, assisted by a policeman on point duty. In the 1970s a flyover road was constructed to take the through traffic straight over the five crossing points, and local access was provided for under, and around each side, of the flyover.

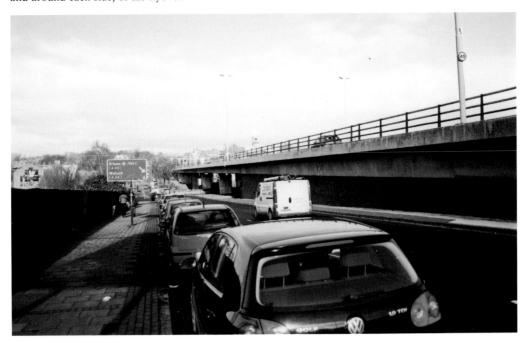

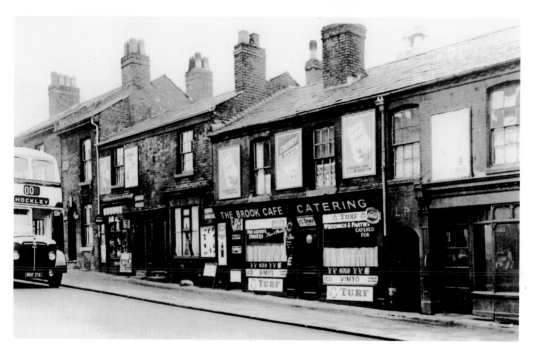

Hockley Hill

An empty bus passing the Brook Café on Hockley Hill travelling to the bus garage in Whitmore Street one of the five roads that met at the junction on the Hockley Brook. Now the road is just a single one-way route alongside the flyover. Demolition of the café opened up the view behind to reveal the former Icknield Street School.

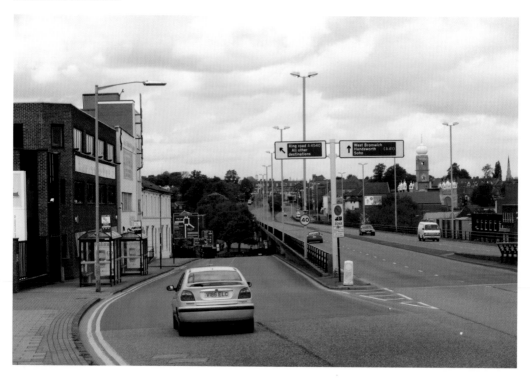

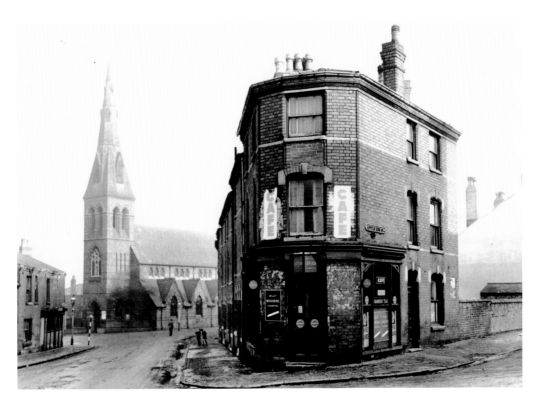

St Saviour's Church

Another café on the corner of Little King Street and Guest Street fed the workers from factories in this area until it was lost together with the streets in the 1960/70s redevelopment of the area. A rare survivor of this period has been J.A. Chatwin's St Saviour's church, Hockley, built between 1871 and 1874 and shown in the early photograph. By the time of the later photograph St Saviour's church located at the side of the new Burbury Park in Farm Street had suffered considerable alterations.

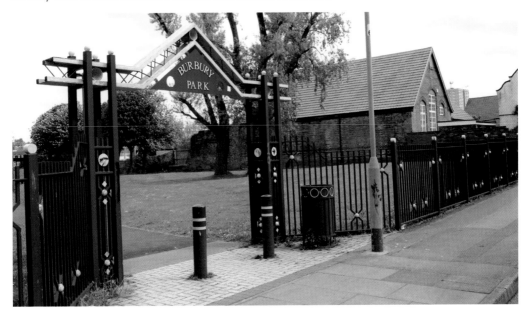

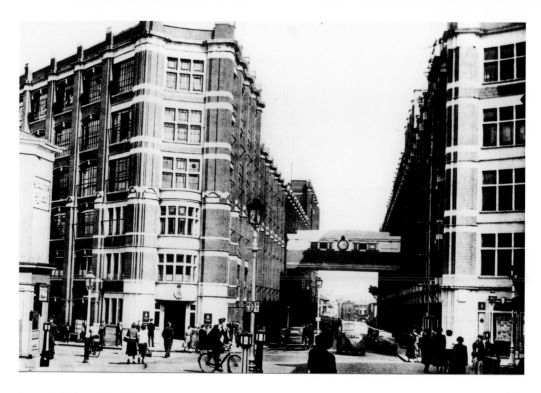

Lucas Ltd, Great King Street

In 1872 Joseph Lucas moved his lanterns and lamp business from Carver Street to Great King Street, Hockley. His business continued to expand eventually resulting in the two buildings shown in the early photograph being built. The Lucas Empire in Hockley employed many hundreds of local people producing electrical components for the car industry. Regeneration in the 1960/70s removed the Lucas buildings and as shown in the 2009 photograph only a stone monument remains engraved 'Lucas Industries Limited 1872'.

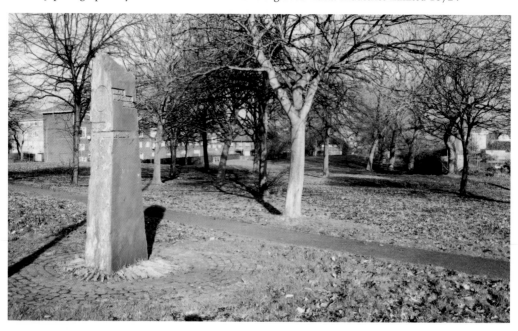

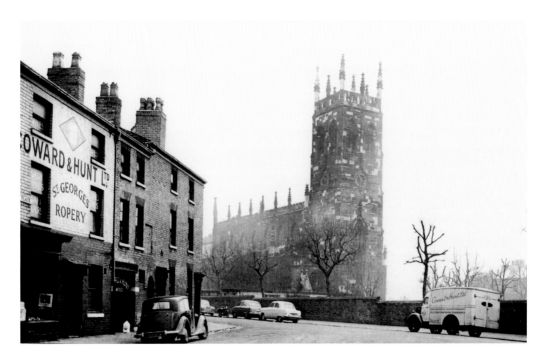

St George's, Hockley

Thomas Rickman designed St George's church in 1822 and it was demolished in 1960. The land where the church once stood has been converted into a churchyard/park. Rickman died in 1841 and his tomb was placed in the churchyard and is visible in the centre of the latest photograph.

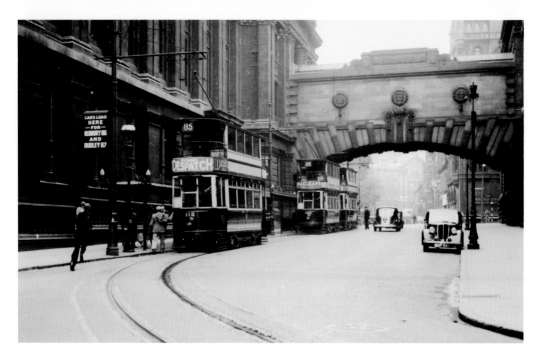

Tram Terminus Edmond Street, Birmingham

Trams and – from the 1950s – buses that served Winson Green and Brookfields began the return journey from the city outside the Gas Hall situated at the rear of the Museum and Council House in Edmund Street. Public transport no longer use this site, it is now an enclosed pedestrian area that only council vehicles are allowed to drive over.

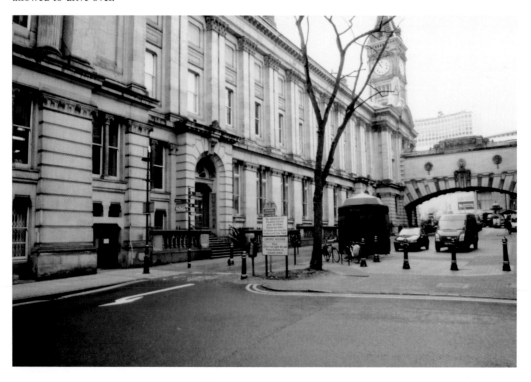

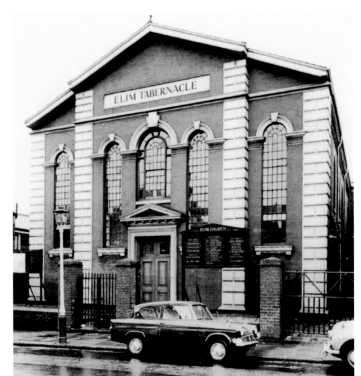

Elim Tabernacle, Graham Street, Jewellery Quarter

Mount Zion Chapel, Graham Street was opened in 1824. For two years, 1844–1846, George Dawson's ministry made this chapel one of the most successful in Birmingham. The building has been used by other faiths since. When the early photograph was taken it was the Elim Tabernacle, in 2008 the name above the door is Ramgarhia Sikh Temple.

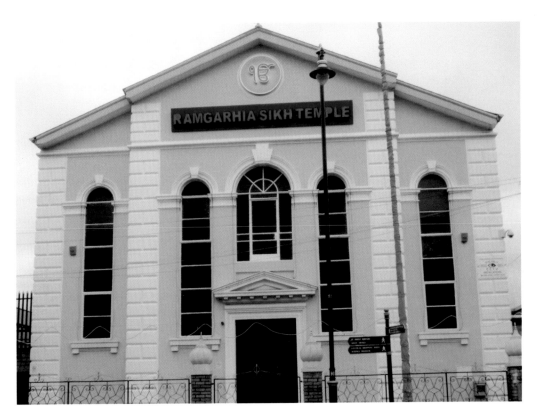

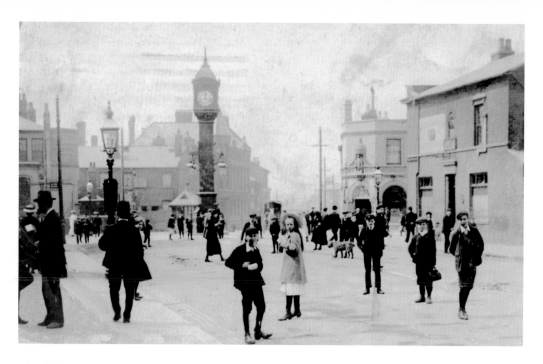

Chamberlain's Clock, Jewellery Quarter

Chamberlain's clock tower was erected in 1903 to the Rt. Hon. Joseph Chamberlain MP, Mayor of Birmingham 1873–5, in recognition of the work he had achieved for the city and the world famous Jewellery Quarter. The clock stands on a small island at the junction of Warstone Lane, Vyse Street & Frederick Street. Both photographs were taken in Frederick Street facing the clock and Vyse Street, where only minor changes have taken place in over 100 years.

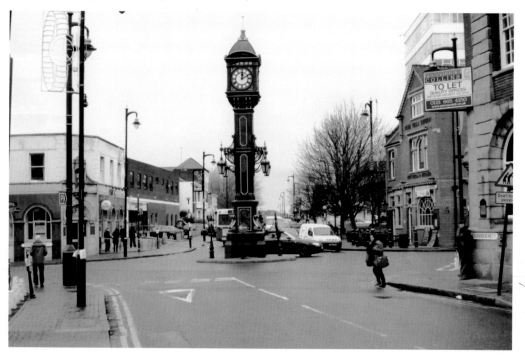

Railway Crossing Icknield Street, Brookfields

This railway bridge crossing Icknield Street is the boundary dividing Brookfields and Hockley. Suspended on the bridge were offices belonging to the railway goods yard in Pitsford Street that crossed Icknield Street at this point. Currently the road has been converted into a duel carriageway; the bridge is minus the offices and a shed-type industrial structure advertising Mr Tyre Ltd. is now displayed at the boundary.

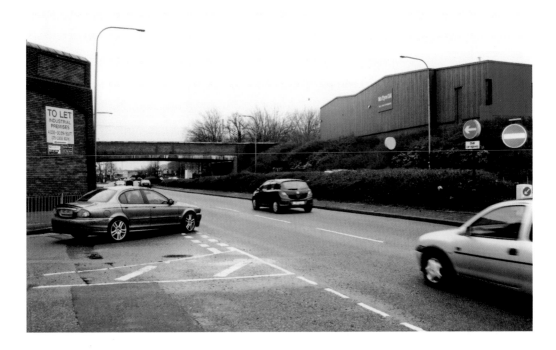

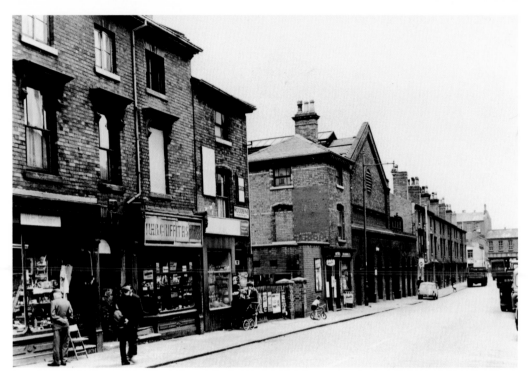

Shops, Icknield Street

Shops, houses and factories closely built together front Icknield Street in the 1960s. They were demolished to make way for a road widening scheme. Today, with the new duel carriageway in operation, big advertising boards occupy a large area of unused land.

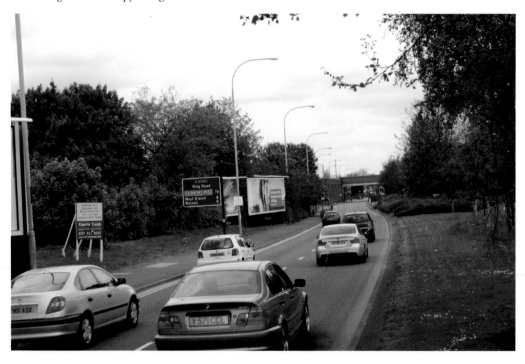

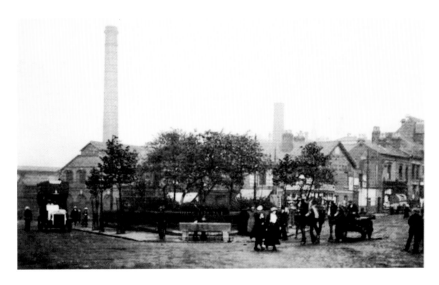

Public Conveniences, Icknield Street, Warstone Lane

Transport was beginning to change in this early twentieth-century photograph. With a motorized vehicle travelling along Icknield Street towards Ladywood and three horse drawn carts arriving from the Jewellery Quarter down Warstone Lane with a horse trough in the centre. A large chimney stack from the mint factory is visible in this and the later photograph when the young trees, having matured, surround a closed ladies and gents public convenience.

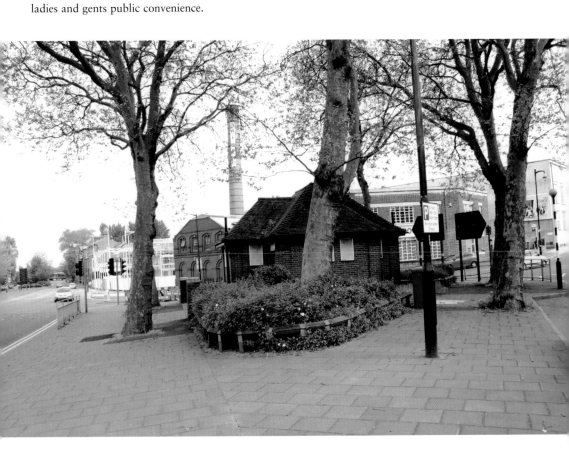

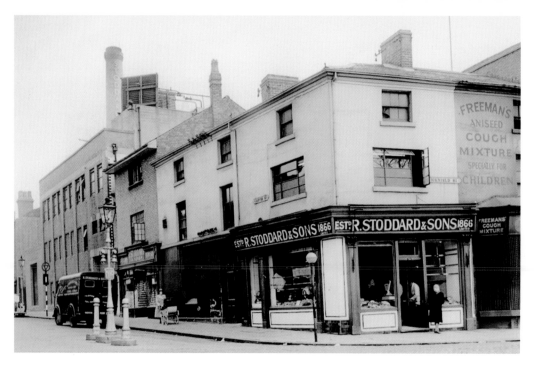

R. Stoddard & Sons, Carver Street

Stoddards the pork butchers had shops on many high streets and shopping centres. Seen here in the 1950s is their Carver Street meat processing factory, premises and shops. A double fronted butchers shop occupies the corner of Carver Street, adjoining is their provisions shop and factory complete with a chimney stack. Today Gallery 54 has moved into the corner shop and an insurance firm now occupies the other shop and factory. Note the modern advertising above the old factory.

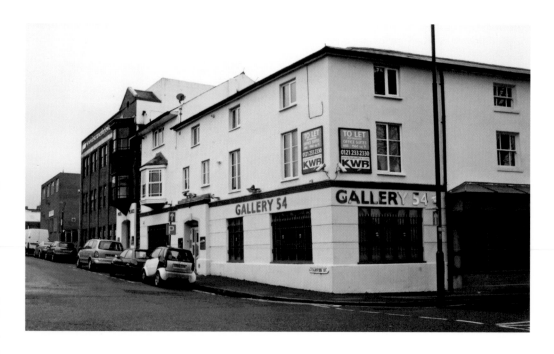

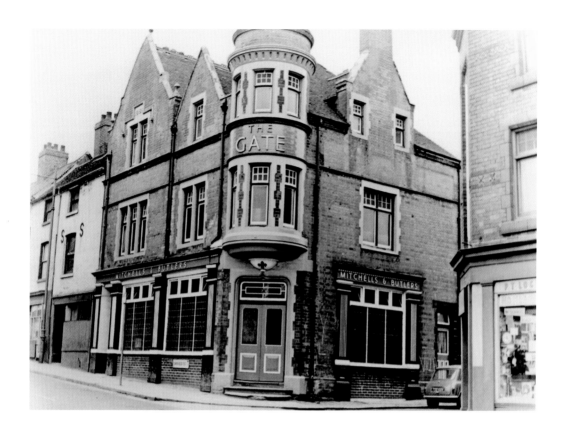

The Gate, Icknield Street

Another public house with an impressive frontage built in 1888 and closed in 1970. The Gate, a Mitchells and Butlers pub stood on one corner of Alfreds Place with Lockwoods house furnishers on the other with a row of houses at the top. Mrs Morgan's fish and chip shop is far left in this 1950s photograph, her daughter Gladys became the film star Elizabeth Kearns and her mother displayed photographs of her all around the shop. All the properties have been replaced by one of the many multi-storey blocks of flats now in Brookfields.

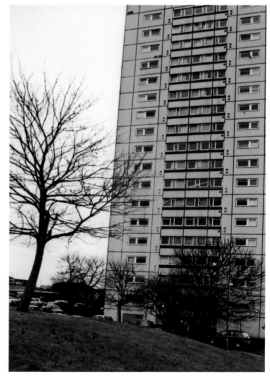

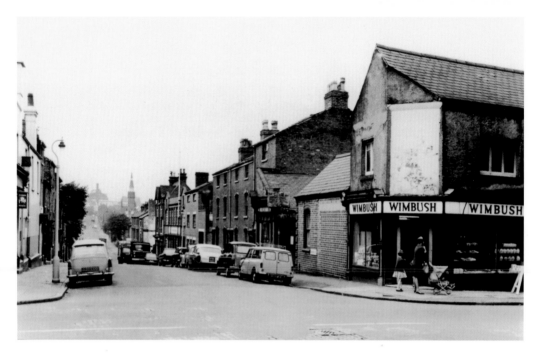

Camden Street, Brookfields
The new face of Camden Street is dominated by Dorset Tower and only the old workhouse laundry building, with its distinguishing chimney stack, still appears on the horizon. Wimbush the bakers and The Warstone public house that served generations of families from its corner location have both been demolished, together with the customers' old houses and the local school.

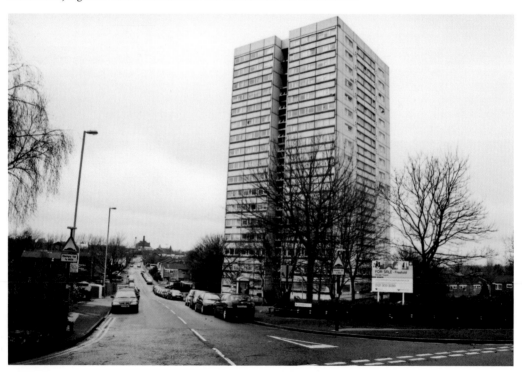

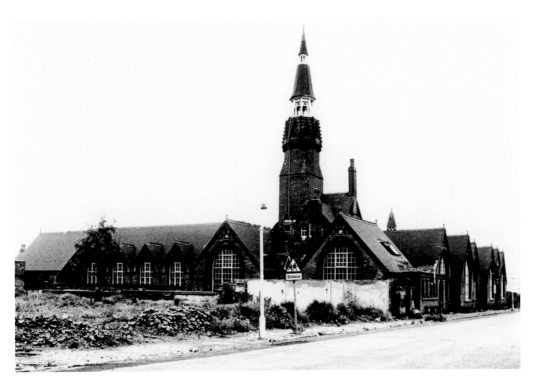

Camden Street School

Camden Street School looking abandoned just before demolition in 1972 without any of the families or old houses that once surrounded the school. The two streets associated with the location of the old school site, George Street West centre of the 2009 photograph and Camden Street, now occupy modern housing with open spaces and in the distance a high rise tower block.

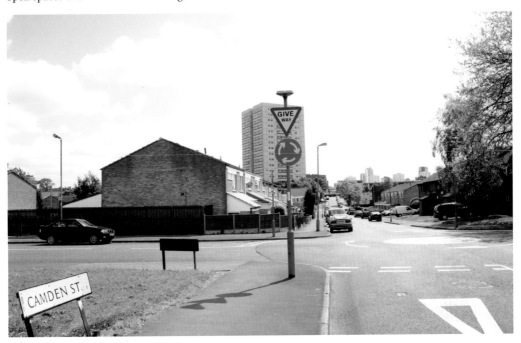

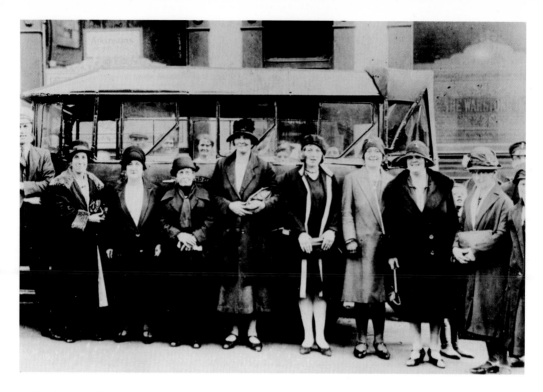

Ladies from The Warstone Going Somewhere

Ladies outside The Warstone public house, Brookfields, dressed up and ready for an outing somewhere. This pub was on the corner of Camden Street, it closed in 1971. There is a Warstone Lane a few roads away where the name may have originated from. A photograph of The Warstone taken in the 1960s looking towards Ladywood displays a row of shops before Spring Hill Library in the distance. Only the library survived the demolition that took place in the 1960/70s.

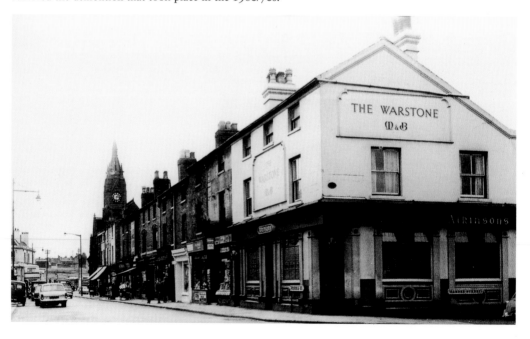

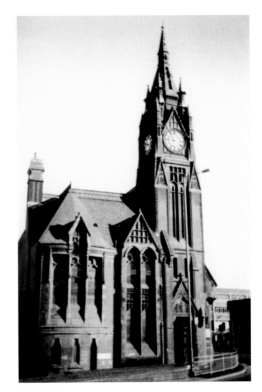

Spring Hill Library
Designed by the Birmingham architects Martin and
Chamberlain and built in red brick and terracotta
the building situated on the corner of Spring Hill
and Icknield Street opened on 7 January 1893. The
tower of this Grade II listed building has four clock
faces that still display the time across Ladywood
and Brookfields.

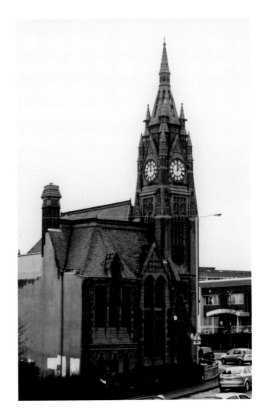

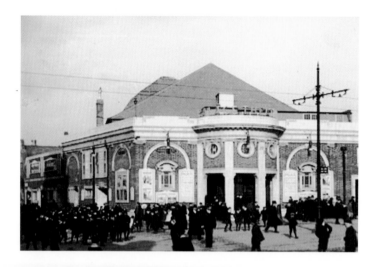

New Palace Theatre

This theatre opened in 1905 on the opposite corner to the library in Summer Hill Road and Icknield Street. Six years later it became the Palace Cinema and closed in 1941 after suffering Second World War bomb damage. Bulpitts manufactured kitchen utensils on the site until it was replaced by the building in the 2009 photograph.

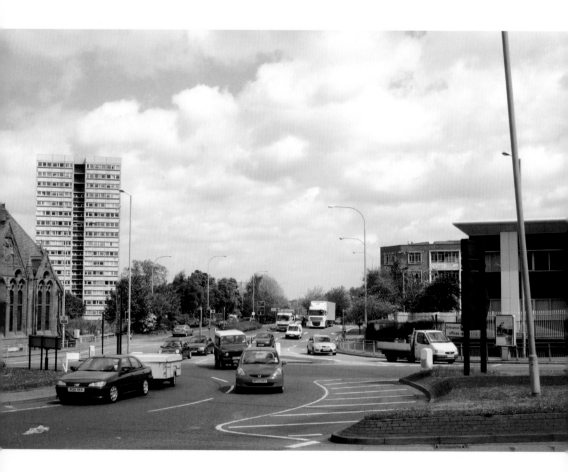

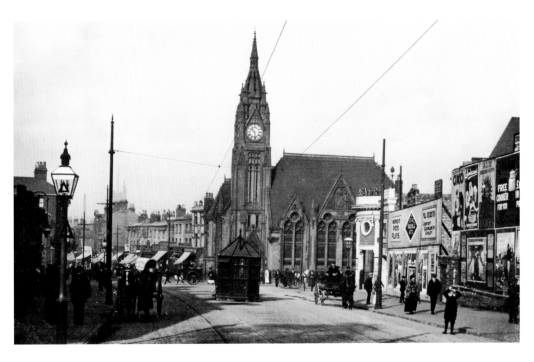

Spring Hill from Summer Hill Road
An early photograph taken in Summer Hill Road, a main route out of Birmingham, towards Dudley. Spring Hill shopping centre is viewed ahead with the library and the theatre in the days of horse drawn transport. Contrasting greatly in the 2009 photograph when motor transport dominates and the road is a duel carriageway, only the library still remains from the past.

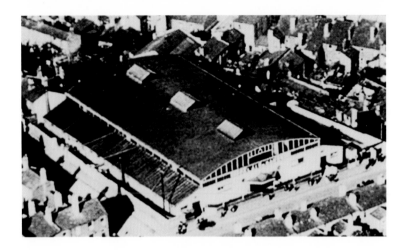

Palais de Dance
An aerial view of this popular dance hall that opened in 1921 on the corner of Monument Road and Ingelby Street Ladywood. During its lifetime it was also used as a circus, roller skating, manufacturing of tyres (First World War) and food storage (Second World War). Finally demolished as part of Ladywood's redevelopment and replaced with a multi-storey block of flats named Salisbury Tower. Ingelby Street disappeared and Monument Road became Ladywood Middleway.

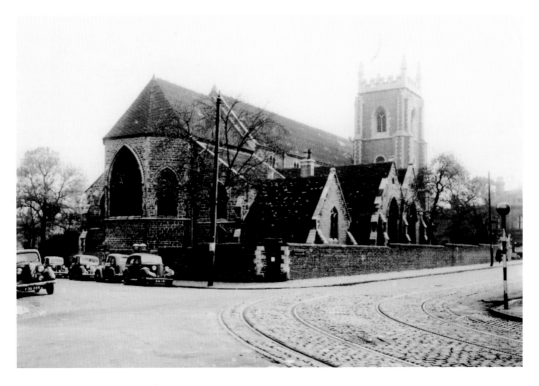

St John's Church

Ladywoods parish chuch built in 1854 and dedicated to St John, today the church stands in the triangle of Wood Street, Darnley and Monument Roads, a timeless reminder of old Ladywood. Having survived the redevelopment of the 1960/70s that changed Ladywood beyond recognition, the church is now known as the Parish Church of St John and St Peter.

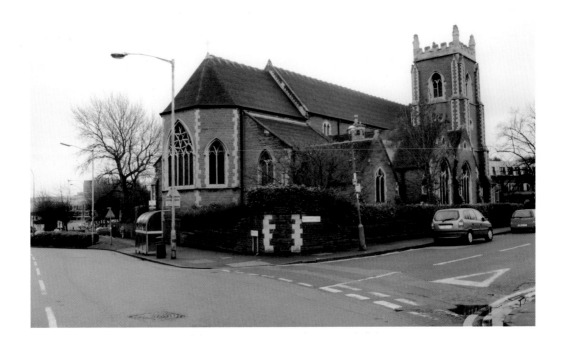

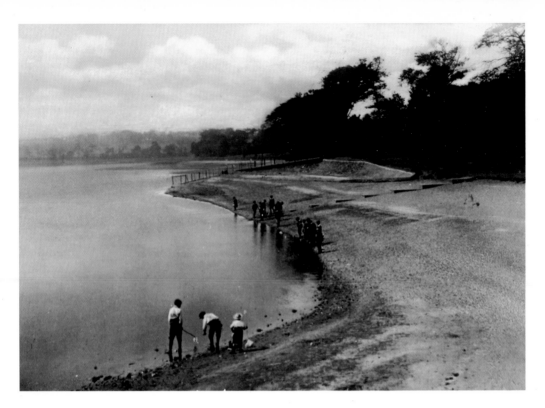

Edgbaston Reservoir

Currently the reservoir is maintained as a Birmingham park accessed via Reservoir Road, Ladywood. Originally it was named Rotton Park Reservoir. It was designed and built in 1826 by Thomas Telford to keep Birmingham's canal network topped up and is still carrying out this function today. The banks extend nearly two miles in diameter and have provided a free rural retreat for families for a number of years.

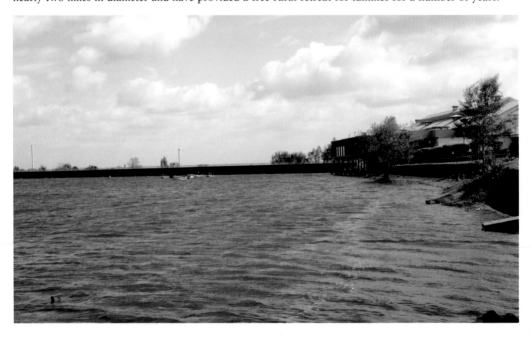

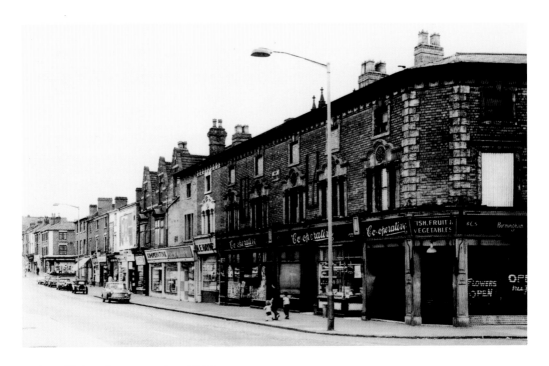

Spring Hill Shopping Centre, Brookfields
One side of Spring Hill is Ladywood, the side that the Co-operative shop was on is Brookfields. Combined they provided a large shopping centre from the library to George Street West. Ellen Street corner, where the Co-op used to be, is now a grassed verge with the new properties set back from Spring Hill, unlike the shopping centre where doors once opened onto the footpath.

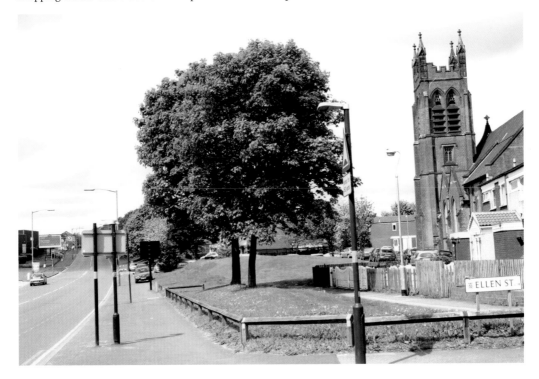

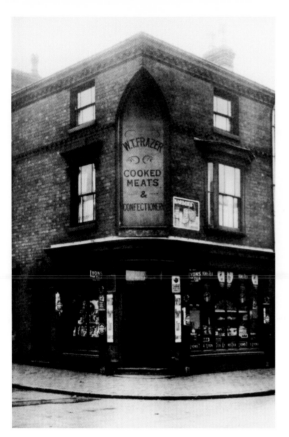

Corner Shop, Ellen Street
Typical of many small corner shops that disappeared when the area was cleared under redevelopment. W. T. Frazer once had this corner shop in Ellen Street providing the groceries for local families despite there being a large shopping area a few yards away. Not all the clearance has been utilized as the 2009 photograph taken on the other corner to the Co-op demonstrates.

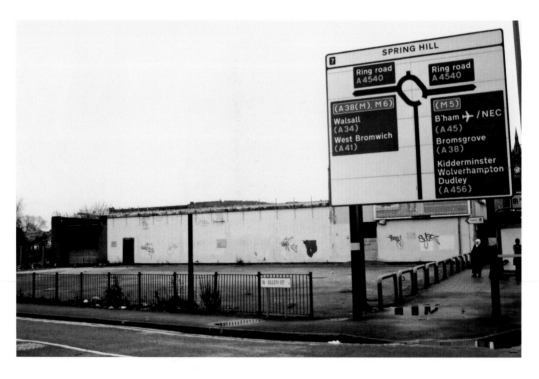

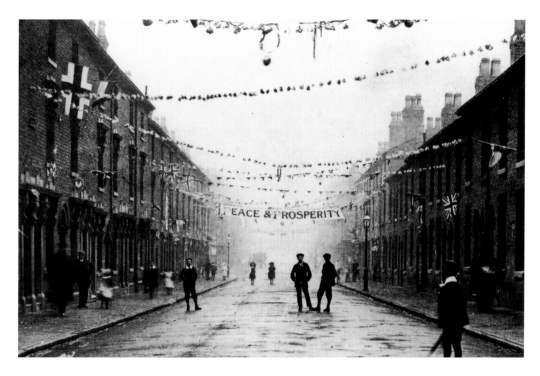

New Spring Street

A street scene celebrating the end of the First World War, 1918, with patriotic flags draped from windows and strung across New Spring Street. The peace and prosperity (homes for heroes) they were expecting did not arrive for a number of years following this photograph. Families still lived in the old houses until the 1960/70s clearance that provided the current view of this street.

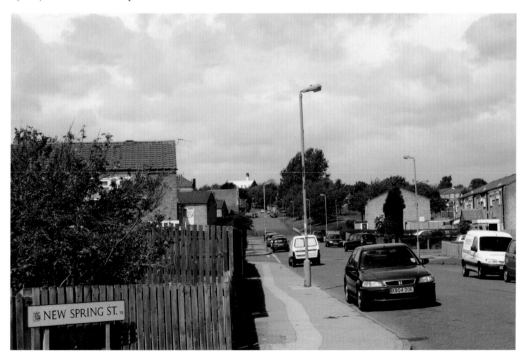

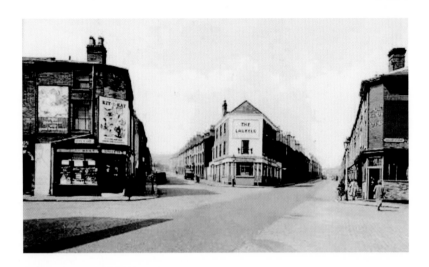

The Laurels
Positioned at the junction of Prescott Street to the left, Higestion Street straight ahead and George Street West that crossed at this point, The Laurels public house was a well-known land mark. Hundreds of families lived in close proximity of this pub and of each other. The streets then contrast greatly with the 2009 photograph of open spaces without shops or public houses.

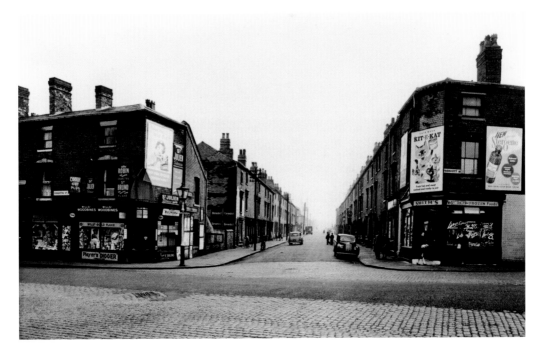

Corner Shops, George Street West

Looking down George Street West towards Spring Hill, large advertising boards brighten up the shops on each corner. In the foreground a strip of tarmac occupies the centre of the cobblestones and replaces the tram lines that were removed in the 1950s. Today a scene not out of place in any country village has replaced the back-to-back housing where *Cathy Come Home* was filmed.

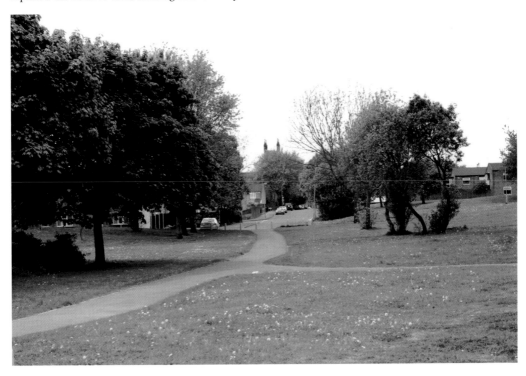

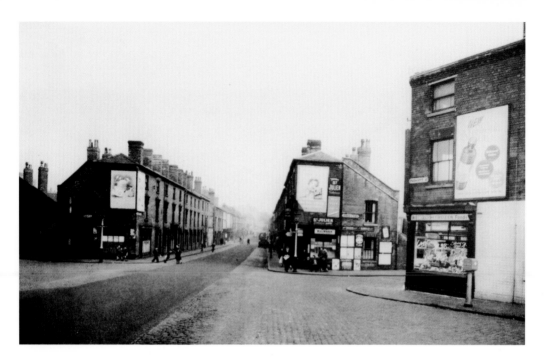

Hingestion Street

Before the age of mass telecommunications when raising the fire brigade meant finding and breaking the glass front of the pillar shown on the right of the photograph, outside the shop. Hingestion Street has always been straight with a moderate incline on which the No. 32 tram, and later the 96 bus route used. Now this well-known street has been realigned with only a few yards of the original line recognisable and all the old houses removed.

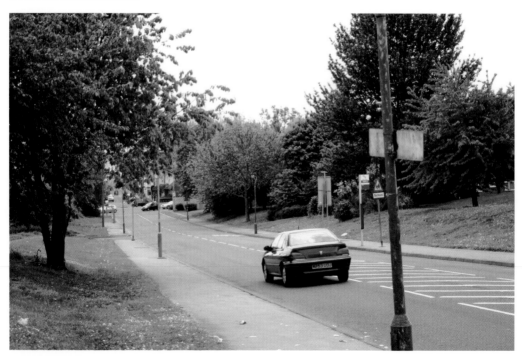

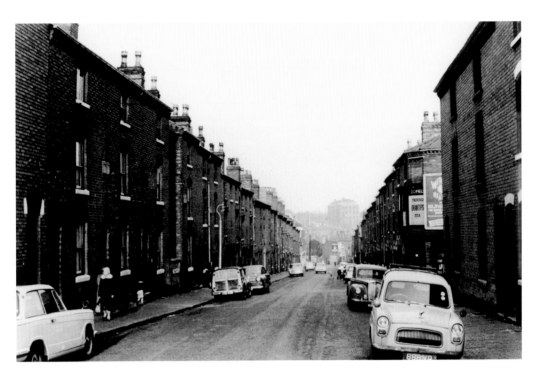

Prescott Street, Brookfields

The topography of the area is clearly demonstrated looking down Prescott Street towards Icknield Street before the land rises again towards the Jewellery Quarter. Only a part of the horizon on the early photograph can be seen through the houses but opens up on the later one together with trees and green spaces. Both show, in the distance, The Big Peg, a large Jewellery Quarter building in Warstone Lane.

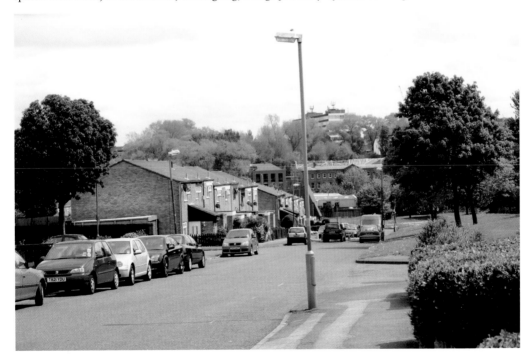

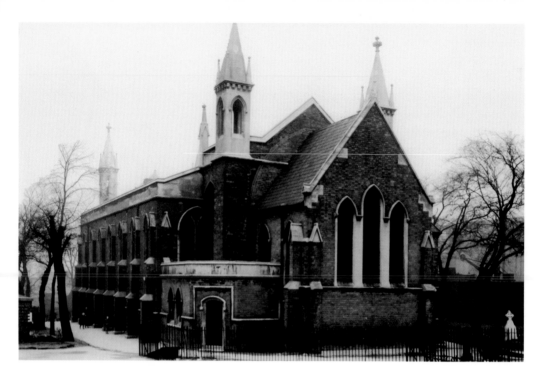

All Saints' Church and School

In 1833 All Saints' Church opened as the parish church for what was becoming a very large populated district. Then in 1843 All Saints' School was erected as an early national school on land adjacent to the church. In its first year the school accommodated 616 boys, girls and infants in three separate class areas. The church was demolished in 1973 in an area where most of the nineteenth-century houses were being demolished. The school building has survived and is used currently by the Birmingham young offenders team.

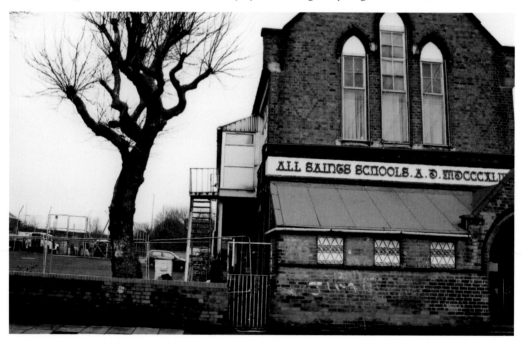

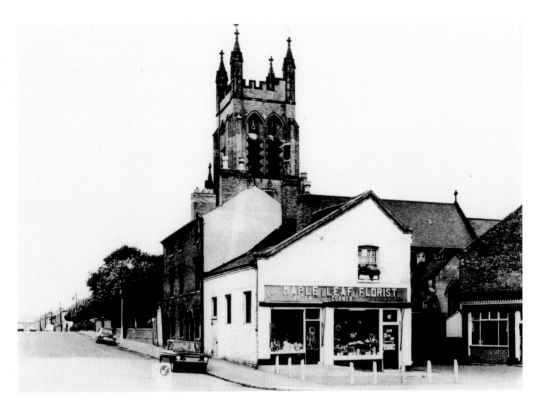

St Peter's Church

Renamed the New Testament Church of God. The St Peter's link migrated to the Ladywood Church of St John. Located in George Street West, St Peter's church was constructed in 1907. Only the bell tower is visible in this early photograph surrounded by houses, a florist shop and the Coach and Horses public house. Following the regeneration of Spring Hill the full view of the church is now possible with a grass frontage.

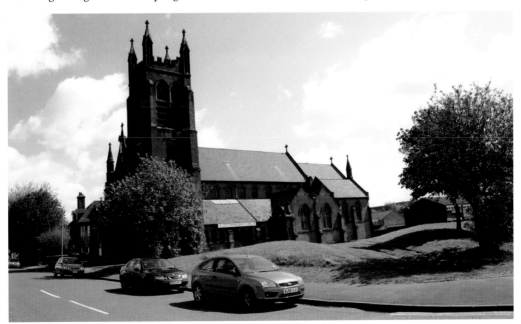

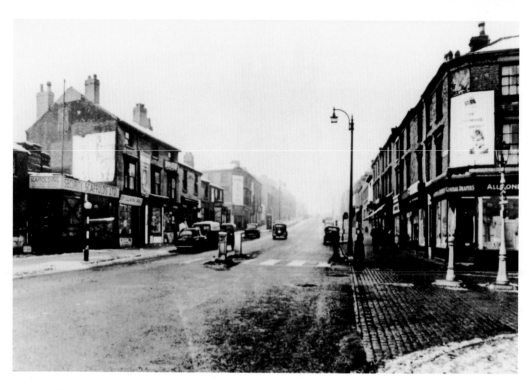

Spring Hill
Young trees and industrial units have replaced the nineteenth-century shops and housing on Spring Hill. Both photographs were taken, looking towards Dudley Road, from where the main shopping area once stood.

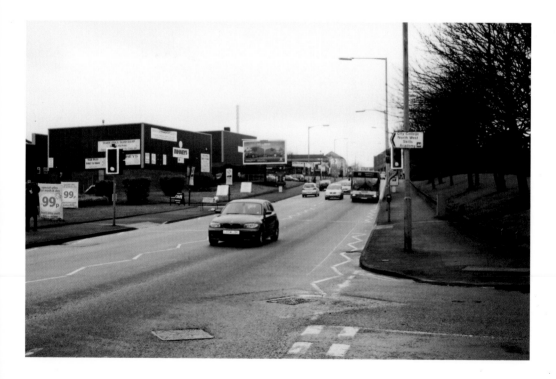

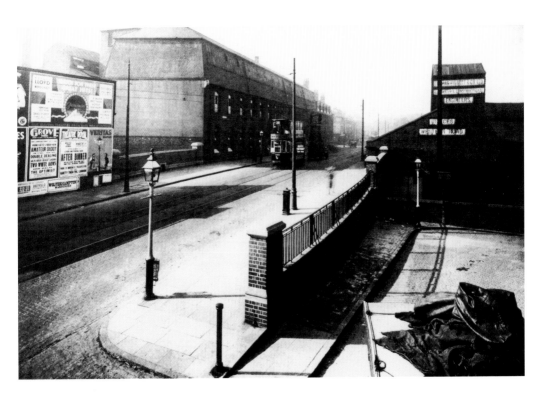

Canal Bridge

Spring Hill and Dudley Road are joined together at the canal bridge. Any usefulness of the canal as a main transport link has long gone together with the canal side industrial properties. Industrial decline is evident in the two photographs, on the left a large rolling mill which has existed since 1904 is almost demolished. Thomas Piggott Engineers' building on the right is now an electrical power station.

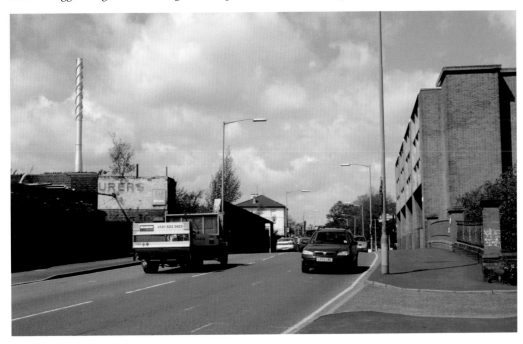

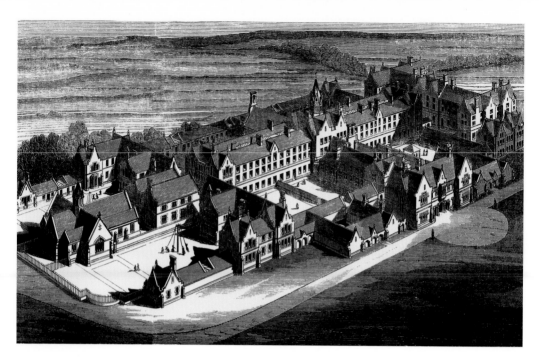

Workhouse

Built on the Birmingham Heath a line drawing shows the buildings of the new Birmingham workhouse. Located in Western Road, Brookfields it was designed by J.J. Bateman and opened on 9 March 1852, replacing Birmingham's old workhouse in Lichfield Street. Today most of the workhouse buildings have been demolished and the land used as a car park for the Dudley Road Hospital recently renamed City Hospital.

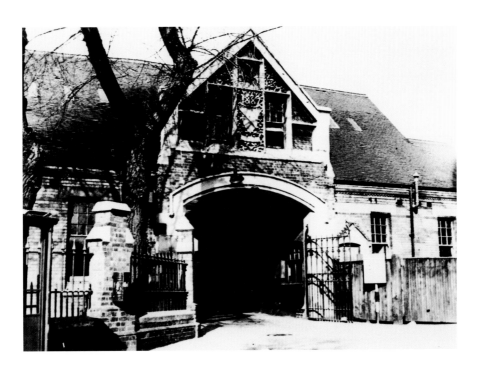

Workhouse Main Entrance

Photograph of the main entrance to the workhouse in Western Road, Brookfields. It was because of their inability to support themselves and their families that thousands of poor souls passed through these gates. The only old workhouse building still standing shown in the later photograph was known as 'The Archway of Tears' where families on entry were separated, males went one way females the other. Western Road marks the boundary between Brookfields and Winson Green.

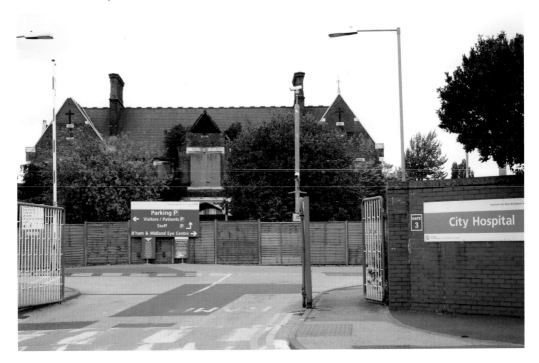

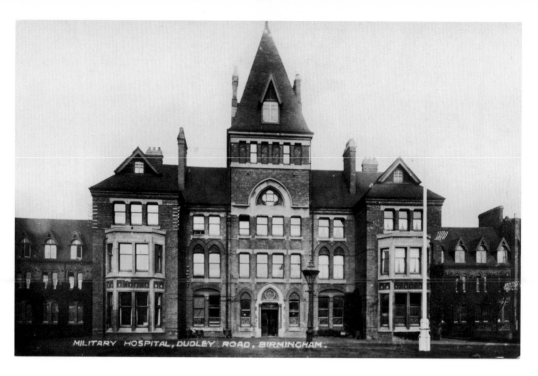

MILITARY HOSPITAL, DUDLEY ROAD, BIRMINGHAM.

Dudley Road Hospital

Formed from the infirmary part of the workhouse the hospital is located on Dudley Road and Western Road with buildings in both Brookfields and Winson Green. Although the hospital has always been known as Dudley Road Hospital by Birmingham people, a recent change of name gives it the new identity of City Hospital.

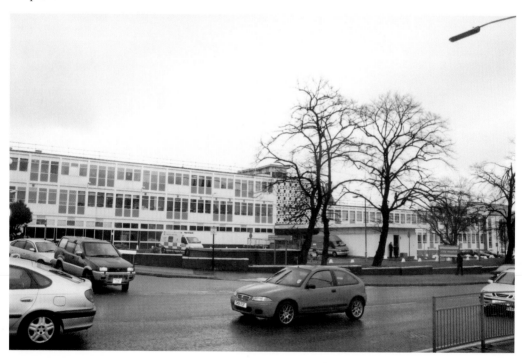

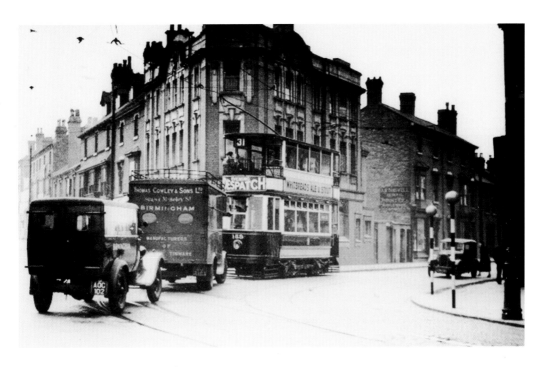

Dudley Road, Heath Street junction

The focal point on both photographs is the splendid building on the corner of Heath Street and Dudley Road. Present day Spices restaurant occupies the building but when the tram passed it was the Lea Bridge Tavern. Crossing Dudley Road at this point since the early nineteenth century is Thomas Telford's new main line canal and a road bridge carries the heavy traffic between Birmingham, Smethwick and Dudley.

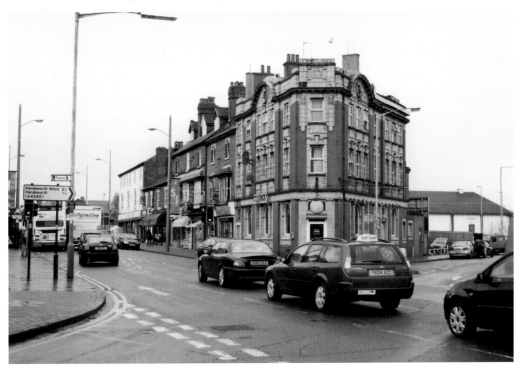

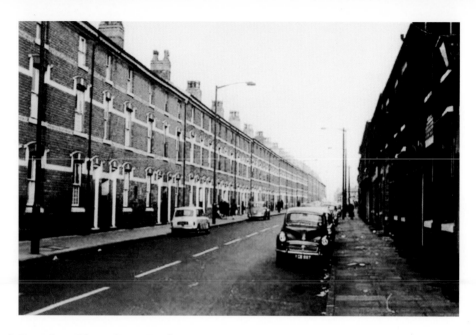

Heath Street from Winson Green Road

A smart row of terraced houses on each side of Heath Street viewed from outside the Shakespeare Arms public house on the corner of Winson Green Road. Only the right-hand side has been redeveloped leaving the other side looking very rural in the latest photograph.

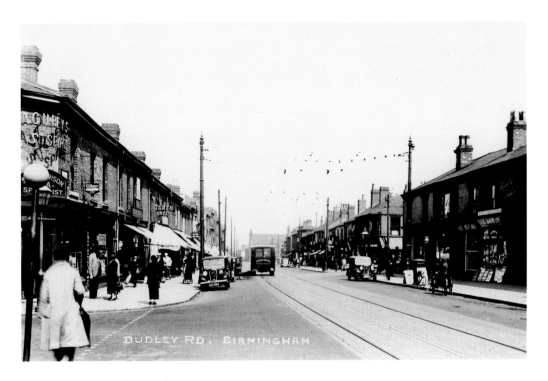

Shopping centre, Dudley Road

Facing towards Birmingham a portion of Dudley Road shopping centre, shops the other way continue up to the Winson Green border with Smethwick. Both photographs were taken from outside the old Dudley Road Board School on the corner of Winson Green Road which opened in 1878 and is still educating the local children today. St Patrick's Roman Catholic church and school is also visible at the far end of the shops.

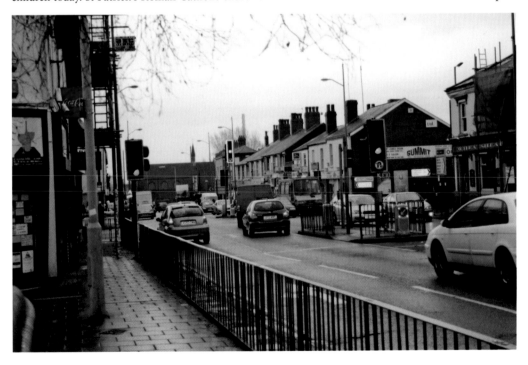

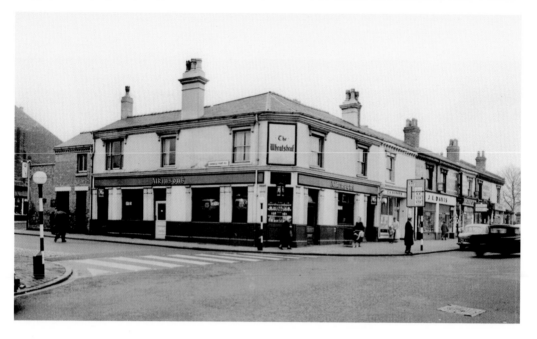

The Wheatsheaf

Spanning the corner of Icknield Port Road and Dudley Road is another grand-looking public house, The Wheatsheaf. Traffic lights have replaced the public road crossing outside the pub and only a reduction to one chimney appears to have occurred to the external structure. Properties attached to the Wheatsheaf and up to Summerfield Park are currently in the process of being demolished.

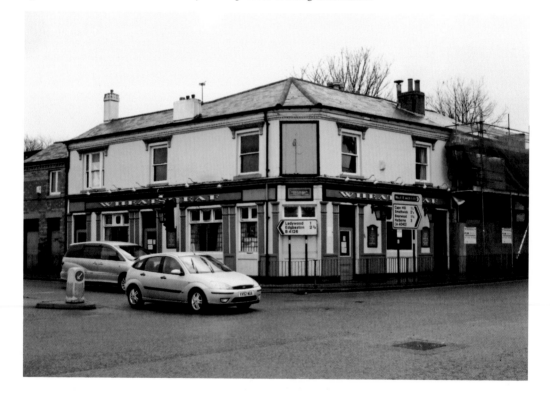

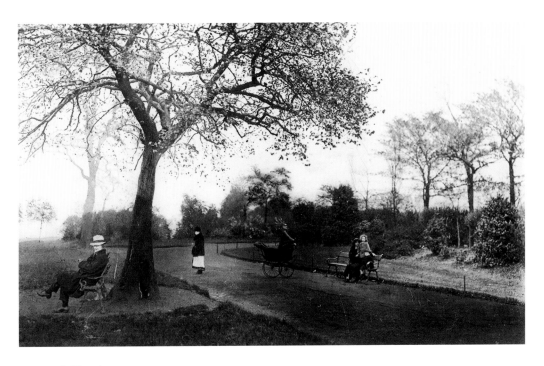

Summerfield Park

This park located on the Dudley Road has provided the one truly green public open space readily accessible to the local people for over 130 years. Summerfield House with twelve acres of land was originally the home of Lucas Chance before it opened as a park on 29 July 1876. Further land was obtained bringing the total acreage of Summerfield Park to thirty-four.

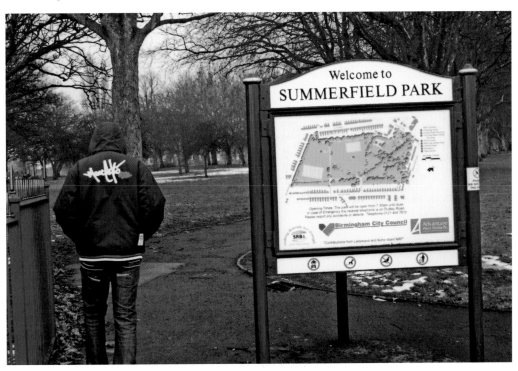

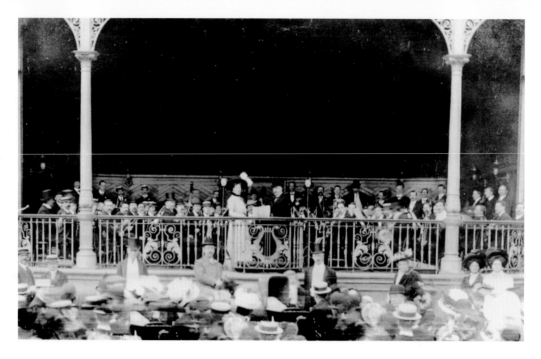

Bandstand in Summerfield Park

Following the demolition of Summerfield House in 1889 the bandstand that appears in both photographs was erected. The Amalgamated Musicians Union Band was playing from the bandstand on 23 May 1909 to an audience of well-dressed people. Sadly 100 years later the bandstand's use has diminished except for the unwelcome work of graffiti artists.

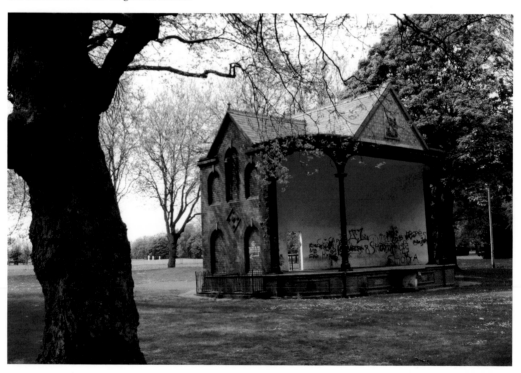

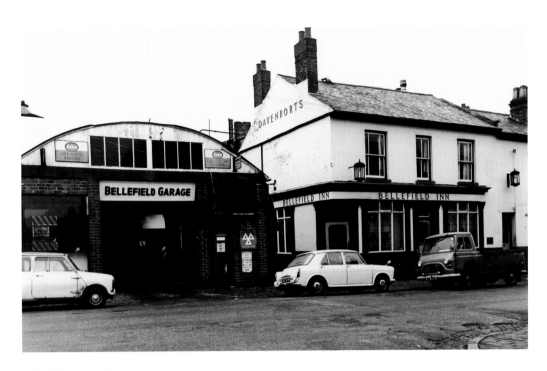

Bellefield Inn, Winson Street

Bellefield Garage has been demolished along with all the terrace and back to back houses that crowded Winson Street up to the 1960s. They have been replaced by newly built modern houses on one side of this street. On the other side a green open space called Molliett Street Play Area has been created. Standing alone on the edge of the play area is the Bellefield Inn a Grade II listed building. This historical inn is currently boarded up and the roof has been exposed to the weather due to recent fire damage.

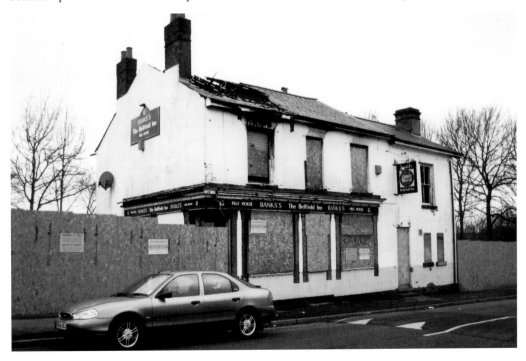

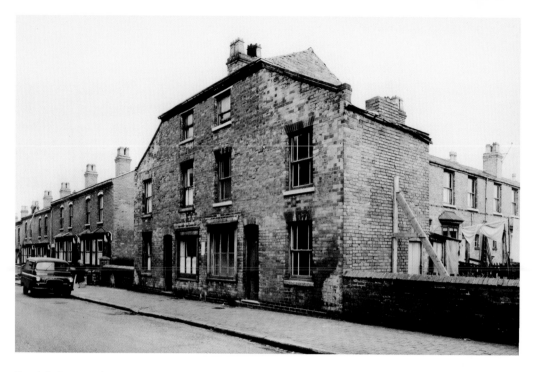

Dugdale Street, Winson Green

In the early 1960s photograph the wall of one house required a wooden support. Not long after it was taken all the houses on that side of Dugdale Street were demolished together with the adjacent Molliett Street and one side of Winson Street. Today where the houses of these streets once stood Molliett Street Play Area has been created. Hudson and Wright's tube making factory once occupied most of the other side of Dugdale Street, although the building remains its usage has changed into small industrial units.

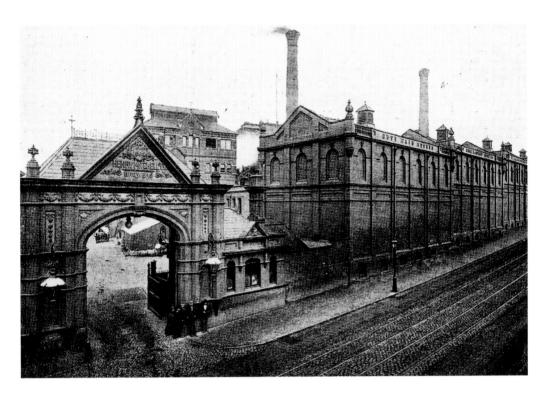

Brewery Cape Hill, Smethwick

In 1878 Henry Mitchell moved his Smethwick family's brewing business to Cape Hill a new site on the Smethwick border with Winson Green. He was joined by William Butler a Birmingham brewer in 1898 when Mitchells and Butlers (M&B) Cape Hill was formed. The closure of this site in the early years of the twenty-first century has resulted in the formation of Mitchells Brook at Cape Hill village shown in the later photograph.

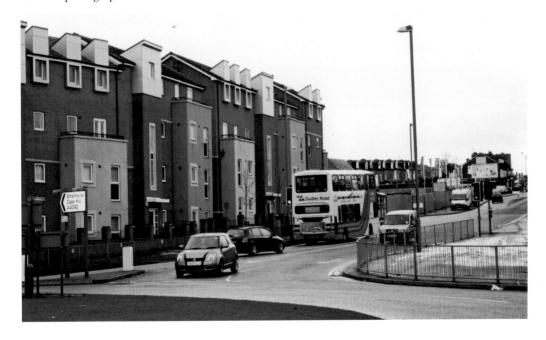

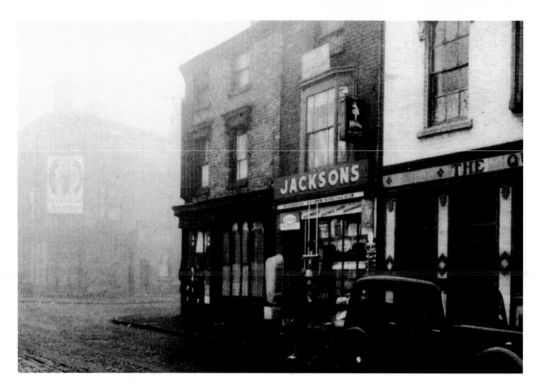

Heath Street, the Smethwick End

An industrial haze lingers at the end of Winson Street in the 1950s Heath Street photograph. This corner of Winson Green on the Smethwick border housed several large industrial factories, including Guest Keen and Nettlefolds the screw manufacturer, contrasting greatly with the light industrial premises normally found in Winson Green. In the 2009 photograph the new houses shine brightly on the corner, and the Queen's Arms public house, with its art nouveau frontage, is still serving customers.

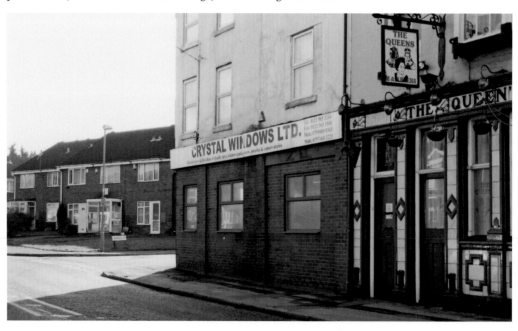

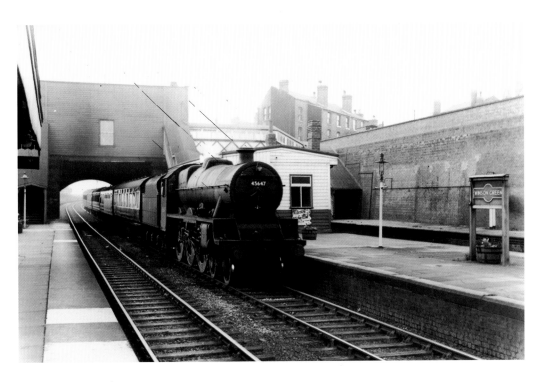

Winson Green Station

The London North East Railway (LNER) opened a station in Winson Green on the line from New Street to Wolverhampton in 1867. Passengers accessed the station from Winson Green Road. Whilst the station was being demolished in 1972 this second photograph was taken from the bedroom window of a back-to-back house, No. 1/102 Aberdeen Street. The backs of houses in Heath Street are visible in the centre of the photograph and the two road bridges spanning the railway and Thomas Telford's main line canal.

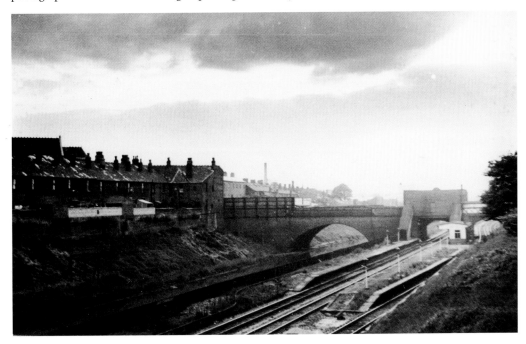

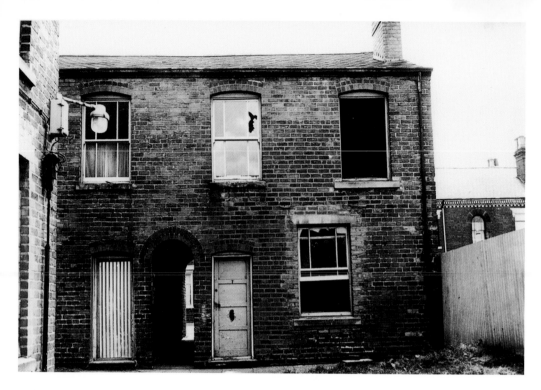

Back-to-back House, Aberdeen Street
No. 7, the back of No. 31, (7/31) Aberdeen Street just before demolition in the early 1970s. Bomb damage during the Second World War created the gap on the right of the photograph; from the gap houses on the opposite side of the street can be seen. In the later photograph, taken approximately where the old house used to be, a more open aspect is offered to the tenants.

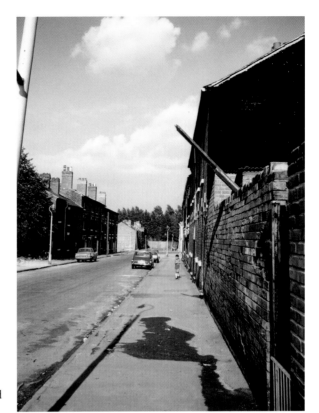

Norman Street

Norman Street viewed from Winson Green Road with a builder's yard behind a brick wall in the foreground of this 1970 photograph. After redevelopment the street still retained a row of the original houses but Peel Street was realigned and entered Norman Street where the wall used to be. Across the road a landscaped scene has replaced the tightly packed houses built there in the late nineteenth century, now the canal and prison wall are visible through the trees.

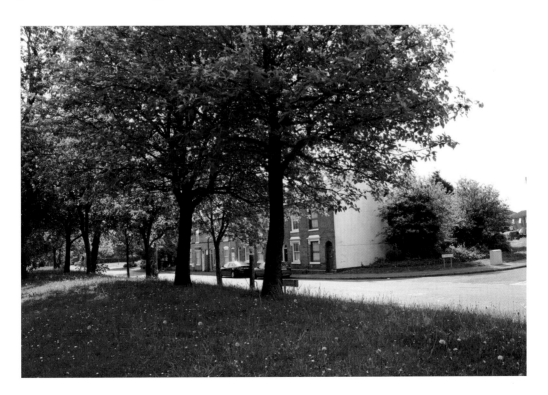

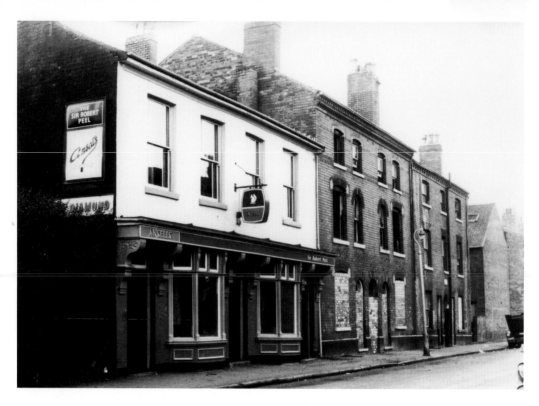

The Sir Robert Peel, Peel Street

Most of Winson Green's back street public houses were lost to redevelopment including the Sir Robert Peel. As each family was re-housed their old house was bricked up awaiting demolition. New houses with front and back gardens replaced the old but they were still overlooked in Peel Street by the hospital buildings at the end of the road.

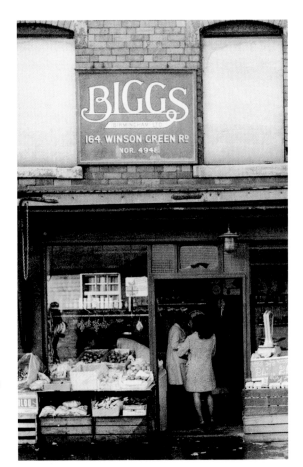

Biggs Greengrocers, Winson Green Road
Six shops along Winson Green Road in 1970
filled the gap between Wellington Street
and Magdela Street. Biggs the greengrocers
traded at No. 164 just before the loop line
canal bridge. Today a window company and
advertising boards fill the gap.

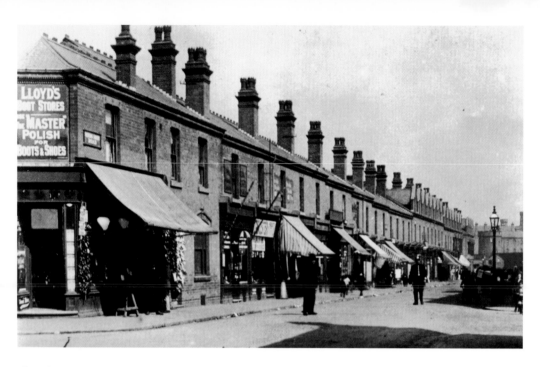

Shopping Centre, Winson Green Road

Winson Green Road shops between Bryant Street and Magdela Street in the early 1900s. A corner shop selling boots and shoes with a barbers shop next door existed here by 1898. At the end of the row of shops the front walls of the prison can be seen. In the later photograph the shops have gone, demolished in the 1970s, revealing the back of the old houses in Blackford Street and the new frontage of the prison.

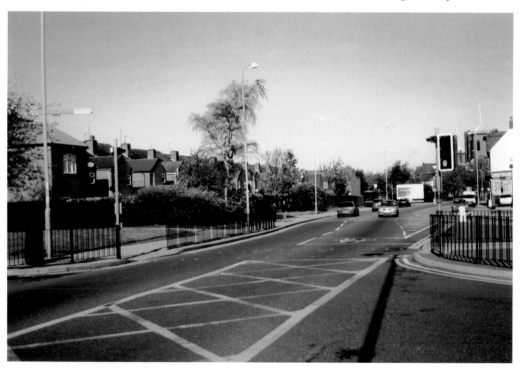

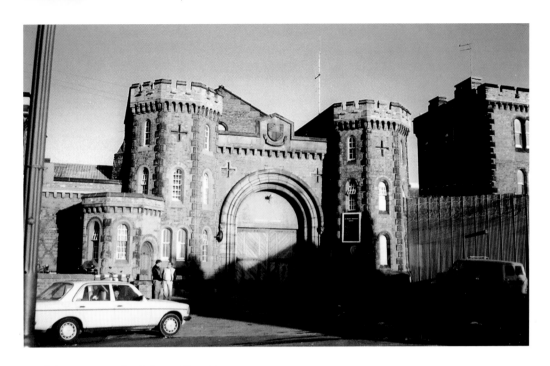

Email from New Zealand, from Albert Evans

'Winson Green prison taken in 1986 while I was on holiday from New Zealand. I took the photo because it reminded me of going to school at Handsworth New Road from my home in Heath Street. My family and I went to New Zealand in 1961 when I was just twelve years old. I am lucky to have this photo because when I took it the prison officers came out and wanted to take the camera and film off me. I had to produce my passport and ID before they believed I was just taking a picture and not planning a jailbreak! The existing wall around the prison was built soon after this photo was taken.'

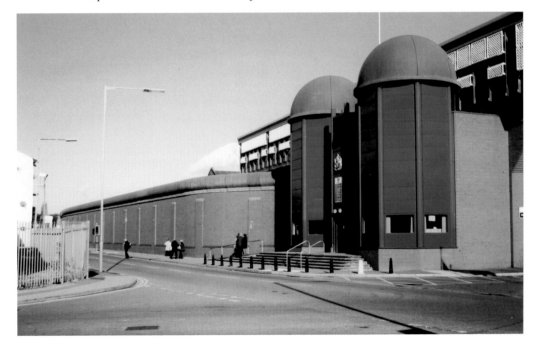

Dedication

This book is dedicated to my children Susan and Stephen and grandchildren Niamh and Niall; they are the future.

Acknowledgements

Following a visit in 2002 to Winson Green, the district of Birmingham where I was born and raised, it was evident that considerable changes had materialised over the many years since I left. Initially it was the period before these changes that I expected to capture when I opened *www.winsongreentobrookfields.co.uk*, a local history website in 2002. As the site name suggests it covers two separate districts, however they are adjacent to each other and share the same social environment.

Materials collected and used on the website arrive in the form of personal stories, photographs and other memorabilia that tell of 'the way we were'. Such recollections are donated from people who once resided, or had relatives who lived, in or around Winson Green and Brookfields. Contributions turn up from home and abroad, each having one common theme running through them: the desire to record before the past gets lost or forgotten in the march of time. They are donated from a great variety of people and places. I would like to thank everyone, especially the following for allowing me to select from their photographs and reproduce them in this book:

Mac Joseph – *www.oldladywood.co.uk*
Birmingham Lives (the Carl Chinn Archive) – *http://lives.bgfl.org/carlchinn/*
John Houghton – *www.astonbrook-through-astonmanor.co.uk*
Birmingham Library and Archives – *www.birmingham.gov.uk*
(Digital Birmingham Photo Archive)

Ken Aston, Matt Chambers, Albert Evans, Margery Elliott, Ken Grinnell, Sonia Jenkinson, Ann Lawson, Andrew Maxim, Chris Ramsbottom, Malcolm Read, Hilary Richards, Andrew Simons.

My wife Maureen for proof reading the project and for her encouragement.
To Susan, our daughter, for accompanying me to the locations for the 2008/9 photographs.

I would also like to thank Amberley Publishing for giving me the opportunity to produce this local history book that describes the changes in Winson Green to Brookfields, mainly environmental, through 180 photographs. Finally, to everyone who reads the book I trust it rekindles memories of the way it was, or still is, for you.

Ted Rudge MA